Table of Contents:

Introduction	1
The Parts of the Fiddle and Bow	2
Useful Things To Keep In Your Case and Practice Area	3
Holding The Bow	4
Rosin	5
Holding The Violin	6
Down And Up Bow Strokes	7
Pizzicato	7
Good Advice For Instrument Owners	8-9
Tuning The Violin	10
Musical Alphabet/Chromatic Scale	11
Reading Tablature	12-13
The Third Finger/Shape 1	13
Warm-Up Page	14
Major Scales And Arpeggios With Slurs	15
Cripple Creek	16
Liza Jane	17
Wildwood Flower	18
Dotted Rhythm Exercise	19
Oh Susanna	19
3/4 Time	20
Amazing Grace	21
Down In The Willow Garden	22
Sally Goodin	23
Eighth of January	24
Shortnin' Bread	25
Boil The Cabbage	26
6/8 Time	27
Swallowtail Jig	27
Auld Lange Syne	28
Angelina Baker	29
Repertoire List	29
Music Reference	30
Warm-Up Exercise	31
A, D, and G Major Scale and Arpeggio With Slurs	32
Cripple Creek	32
Liza Jane	33
Wildwood Flower	34
Oh Susanna	35
Amazing Grace	36
Down In The Willow Garden	37
Sally Goodin	37
Eighth Of January	38
Shortnin' Bread	38
Boil The Cabbage	39
Swallowtail Jig	39
Auld Lange Syne	40
Angelina Baker	41
Repertoire List	41

Introduction

Welcome to Fiddle Book 2 of the Jam Along Series music instructional books. Here we will build on the foundation set by Book 1. If you have not worked through Book 1 and consider yourself a beginner I highly recommend getting book 1 and working through it before beginning Book 2. One of the goals of this series of books is to give the student common repertoire with students of other instruments such as guitar, mandolin, etc. If you know people that play other stringed instruments consider telling them about these books so they can learn the songs you are learning and be able to play music with you.

Hello! I will be appearing throughout the book to offer useful information and learning tips to you.

The Parts of the Fiddle and Bow:

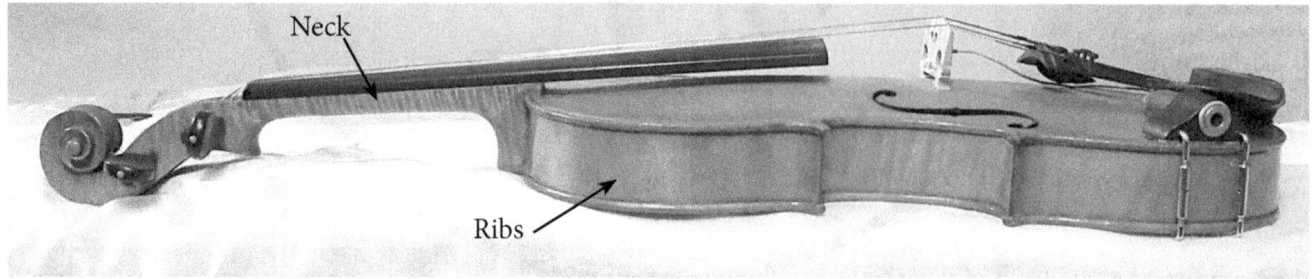

Some useful things to keep in your fiddle case and practice area:

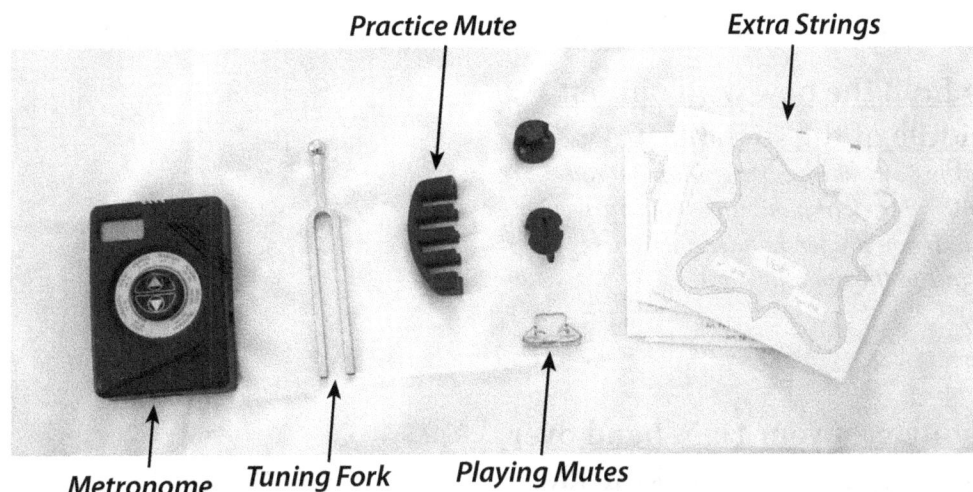

Metronome Tuning Fork Playing Mutes Practice Mute Extra Strings

Rosin

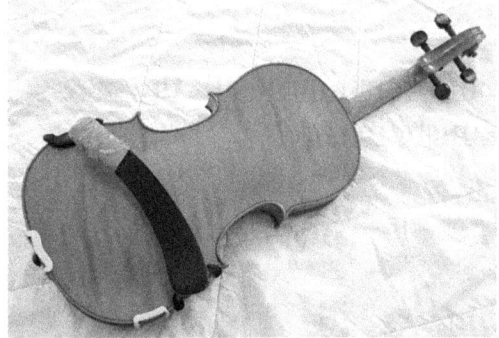

Shoulder Rest

Music Stand

Violin Stand

Section 1
Holding The Bow:

Let's begin with learning how to hold the bow.

First we want to hold the bow with our left hand in the middle of the stick like this:
(Now you can reach the bow with your right hand. You will hold the bow with your right hand unless of course you are left handed. If you are left handed then these steps will shift to the opposite hand.)

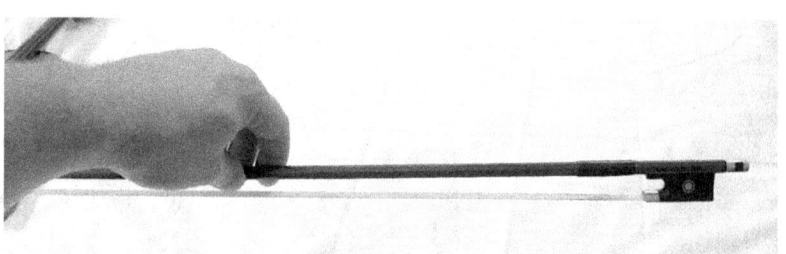

Place the index finger of your right hand over the stick in the area of the second knuckle:
(The finger will lie on stick just up from the frog.)

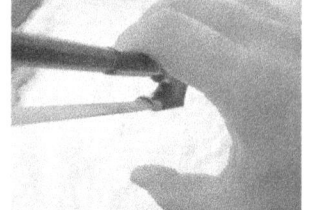 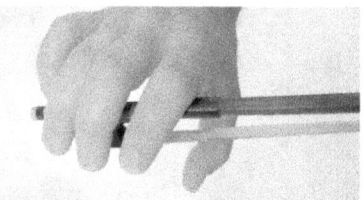

Now bring your thumb underneath the frog to push upward:
(The relationship of the index finger and the thumb are critical to stabilizing the bow in your hand.)

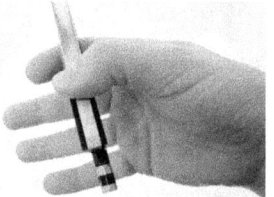 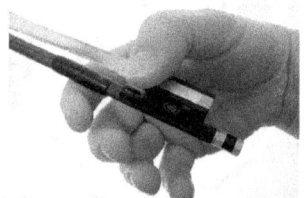

Let your other fingers curl around the stick:
(In a good bow grip all four fingers should be relaxed and all the joints of the hand should be bent. If you take the bow away your hand should be in a comfortable position without awkward angles in the fingers.)

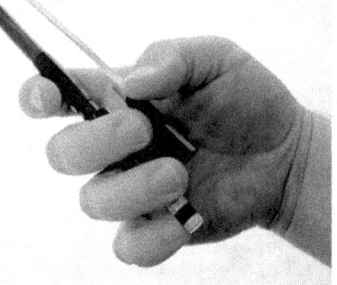 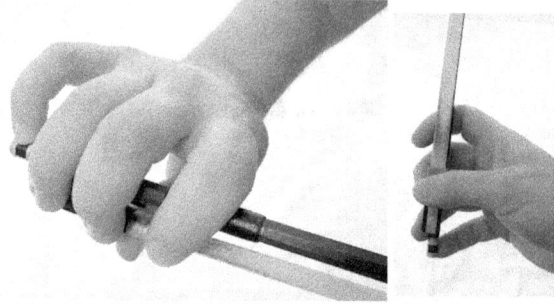

The bow grip acts as a lever whereby pressing down with the index finger sends the tip of the bow downward:

And pressing down with the little finger sends the tip of the bow upward:

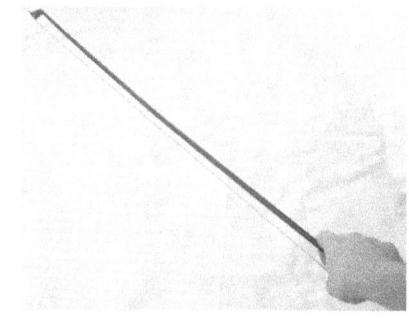

The thumb balances everything in the middle:

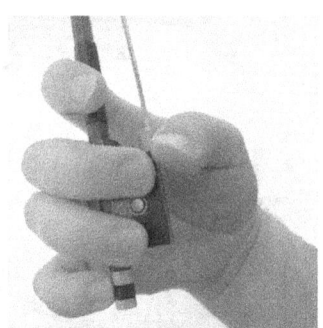

Another option for thumb placement is to angle the tip of the thumb into the stick as shown:

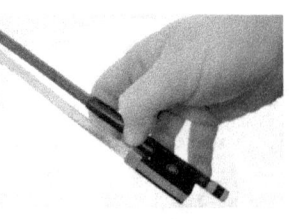

Always remember that your bow grip should be comfortable. If you removed the bow, the hand should appear relaxed and the angles in the fingers should be natural.

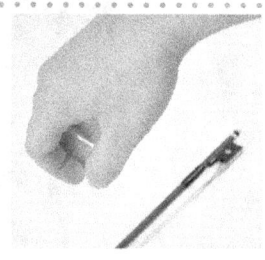

FIDDLE: BOOK ONE

Rosin:

Rosin gives the bow the ability to grip the string when a bow stroke is pulled. Without rosin the bow would not make a sound. If your violin is new and has never been played before then your bow likely needs it's first dose of rosin.

First we want to get out our rosin cake and score it with something sharp like a knife or pin. Score the surface lightly until some dust begins to form.

Scoring The Rosin:

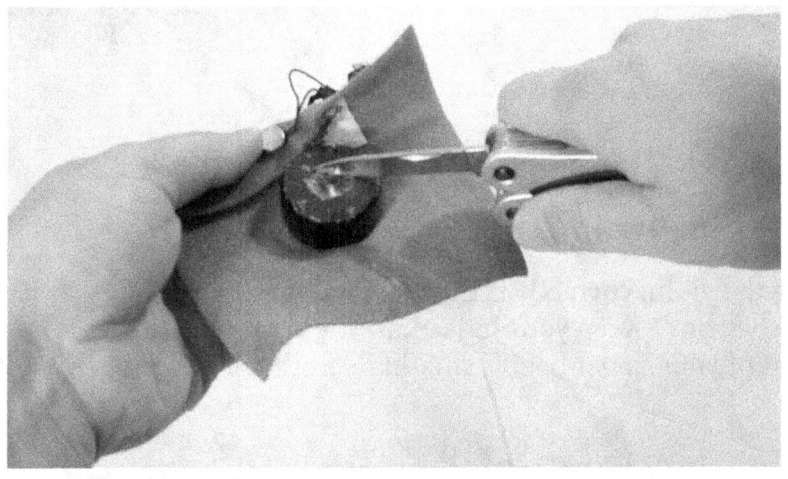

Rosin Dust:

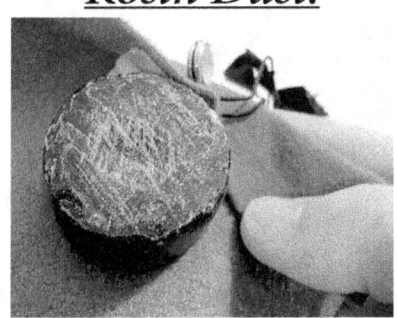

Applying Rosin:

Now that we have some dust on the cake, we can rosin the bow. We want to make sure that we get rosin on all of the bow hair. Begin at the frog and let the bow hair glide across the surface of the rosin cake all the way to the tip. Then head the other way from the tip back to the frog. Press the hair firmly to the cake the entire time you rosin.

1. Begin at the Frog:

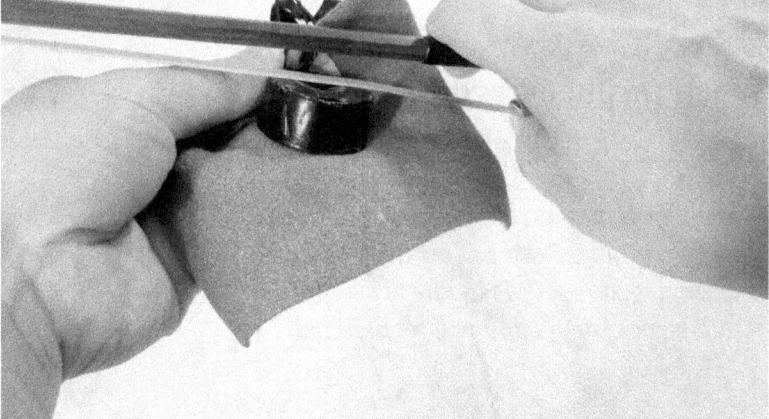

2. Pull the Length of the Bow Across the Cake:

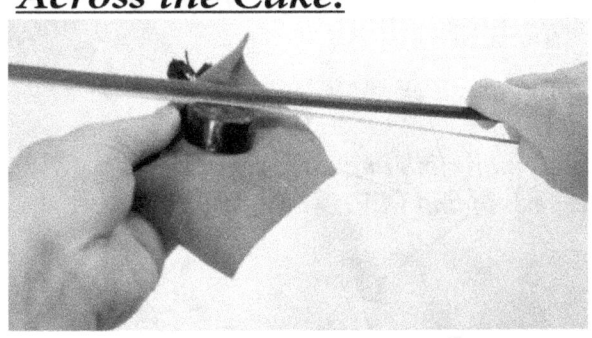

3. End at the Tip and Reverse:

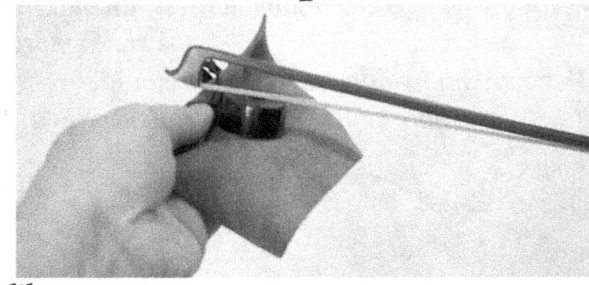

*There are light and dark styles of rosin. Try both and see which one you like.

*Some people use a lot of rosin where others use very little. Experiment with rosin levels to see how much works best for you.

Holding The Violin:

The violin should be held at about a forty-five degree angle away from the body.

Just Right: *Too Far up on the shoulder:* *Too Far in Front of the Body:*

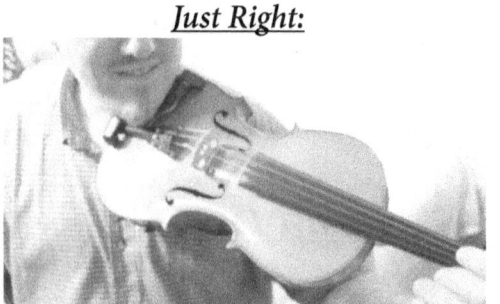 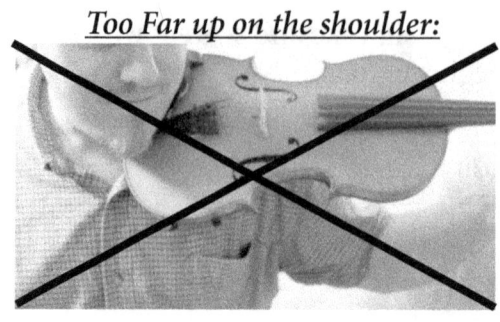 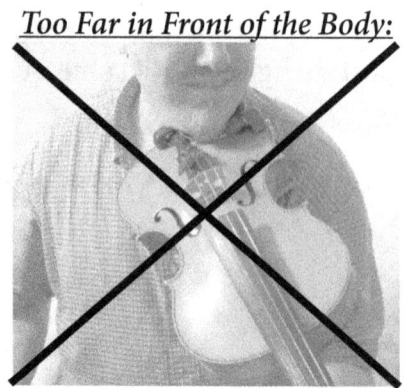

Left Hand Placement:

One of the most critical parts of holding the violin correctly is the left hand placement. The left hand should come around the neck of violin near the peg box. Keep your index knuckle right next to the nut. The point at which your palm ends and the first digit of your finger begins should be flush with the fingerboard.

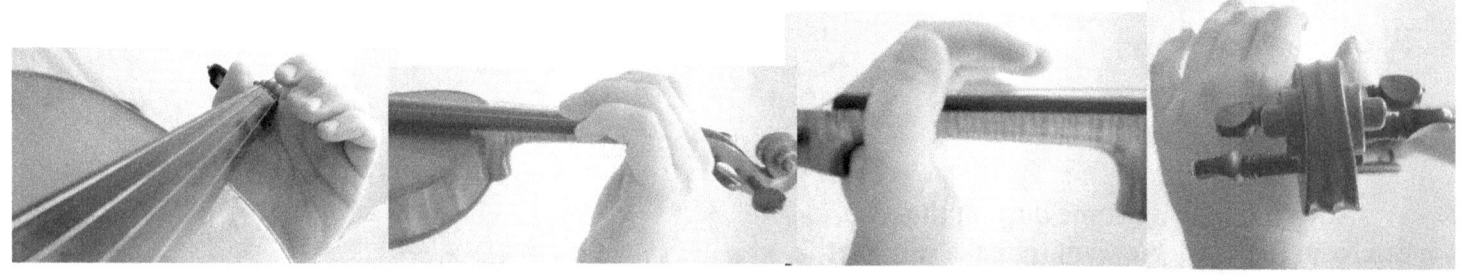

When we put everything together it should look like this:

Note that getting used to holding and using the violin and bow can be very awkward and challenging at first. Make sure to accept this and be persistent. You will get used to it.

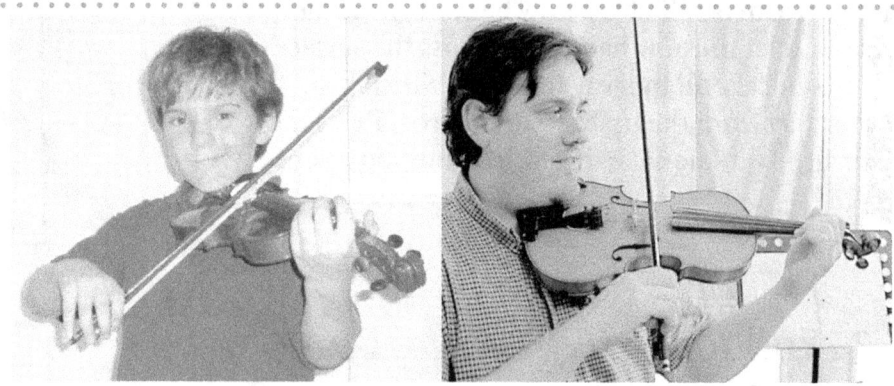

Shoulder Rest

Using a shoulder rest can make it easier to hold the violin. A shoulder rest helps us hold the violin more with our upper body than our arm.

There are many different styles of shoulder rests. Some are as simple as a small cloth and some rubber bands. Others are more elaborate. Experiment with different types of shoulder rests to find which works best for you.

FIDDLE: BOOK ONE

Down and Up Bow Strokes:

- A down bow stroke is pulled from the frog to the tip of the bow traveling downward. The symbol for a down bow is:

- An up bow stroke is pulled from the tip to the frog traveling upward. The symbol for an up bow is:

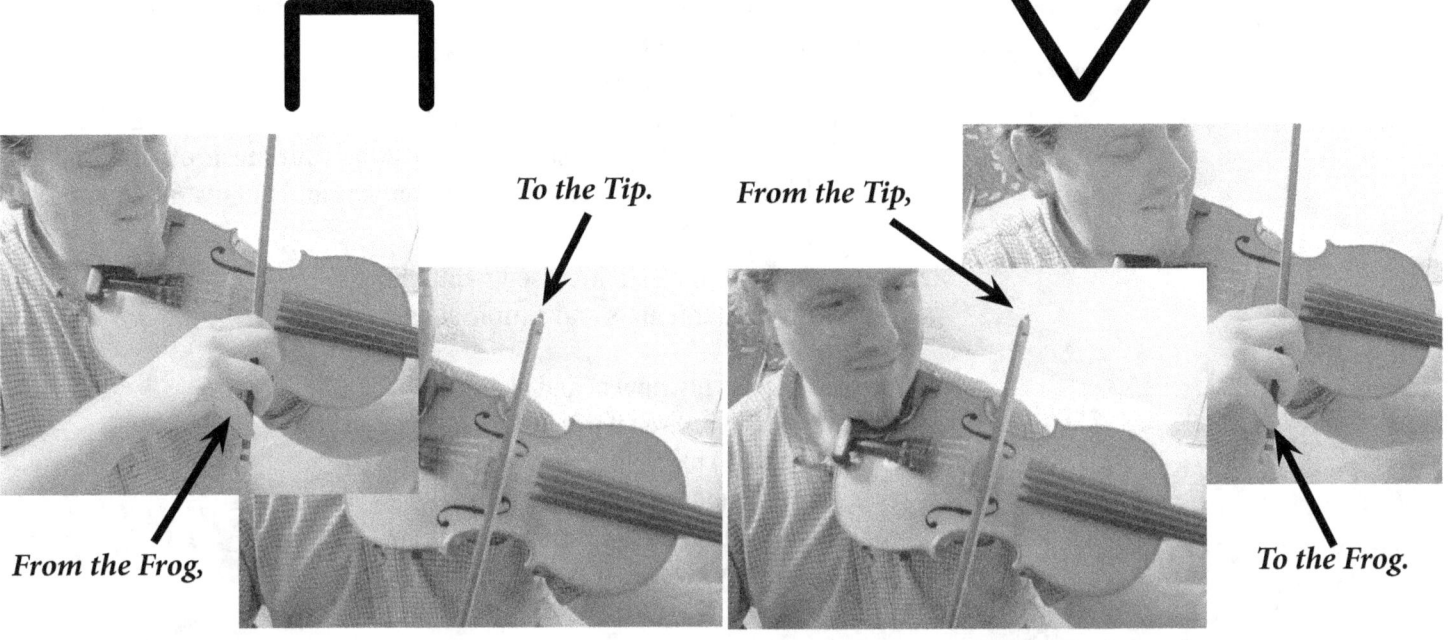

- Be aware that in addition to the bow strokes listed throughout the book, a variety of other bow strokes can be used for any exercise or song.

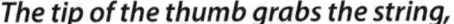

Section G.
Pizzicato:

Pizzicato is means of plucking notes on the violin. In the following exercises and songs you may find it helpful to first play pizzicato, and then bowed.

The tip of the thumb grabs the string,

and gently pulls downward to produce the note.

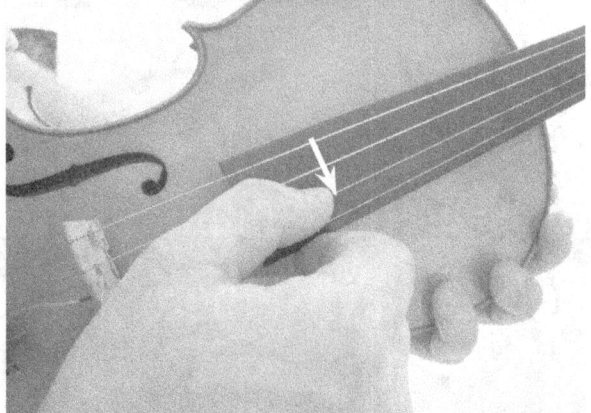
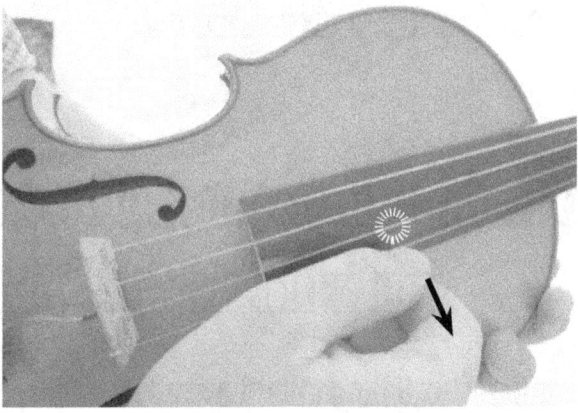

FIDDLE: BOOK ONE

Good Advice For Instrument Owners:

Instruments are susceptible to the elements. Do not expose them to extremes of heat, cold, humidity or dryness whenever possible. Do not leave instruments in hot cars or anywhere else they can be damaged.

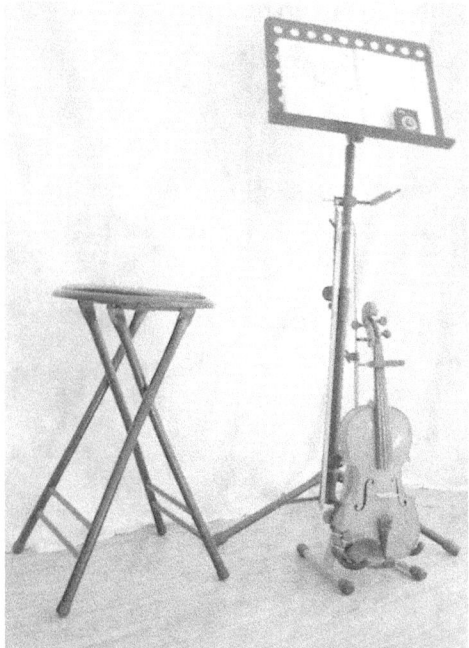

Have a place where you can practice and leave out your instrument and your music. Leaving your instrument out of the case will make you more likely to play it.

Unless you are playing completely by ear, having a music stand is very helpful. You will have better posture when reading your music off of the stand. Ideally this is a place where you can play and not disturb anyone.

Relax and play and play in a focussed manner. Warm-up with fundamentals and simple songs.

Try to pick up your instrument and play every day whenever possible. Even if it is just for fifteen minutes. It is better to play a little everyday than to play several hours, but only on very few days. Seek out people to play music with. Learning to play an instrument ultimately involves playing with others.

Leave instrument out and accessible.

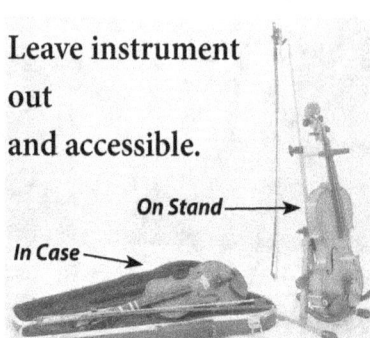

On Stand
In Case

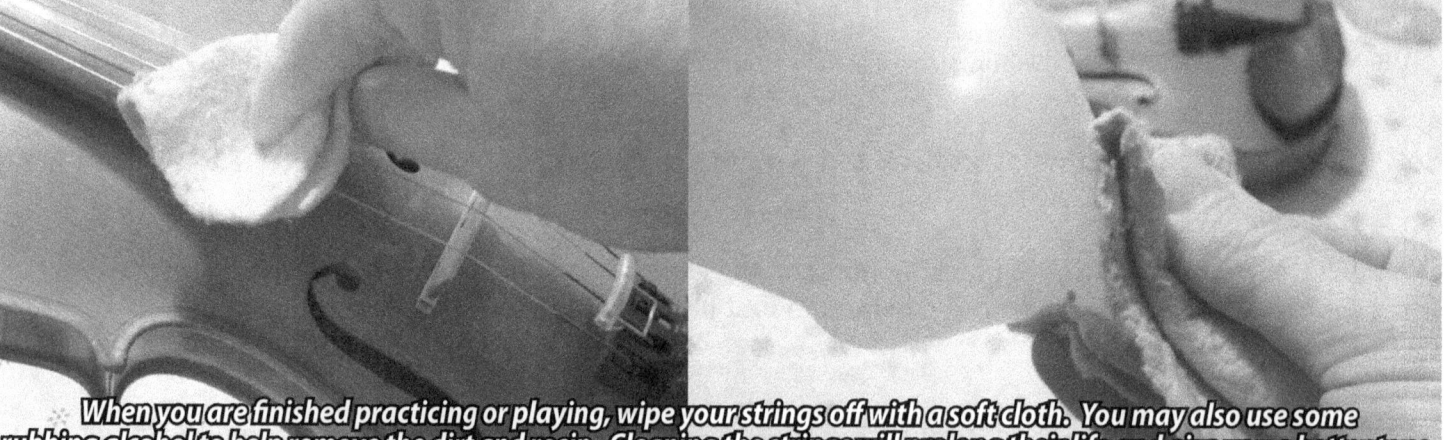

When you are finished practicing or playing, wipe your strings off with a soft cloth. You may also use some rubbing alcohol to help remove the dirt and rosin. Cleaning the strings will prolong their life and give you a better tone.

Listen to the songs you are learning.

Go to Youtube.com, and type into the search: "Jamalongseries" You will find the "Fiddle, Book 2" playlist there.

Go out and watch people play music. Go to concerts, dances, and anywhere else live music is being played. Watching live music will help you understand how musicians coordinate the motions of their bodies to produce the sounds.

FIDDLE: BOOK ONE

Good Advice Continued:

- **Avoid struggling and appreciate any forward progress you make.** If you are struggling with something you are trying to learn you probably aren't making forward progress and could be teaching yourself errors.

 Go slow and play your notes correctly in order. Strive for good, even, consistent tone control in your bow. Playing slow gives you time to correctly tune your notes and keep in time when learning a song. Become good at learning to play slowly and in complete control with the piece of music as you would want it when you will play it in the desired tempo. Doing this will get you to the playing stage with a song more quickly.

 Avoid getting caught up in self-doubt or negative things others say. You alone should determine what is possible for yourself. The most important factors in your learning progression are your attitude and your persistence.

- **Listen to music and pay attention to others when they are playing.** Every time you listen to music or watch and listen to someone else play, you are gaining something in knowledge and experience. Listen to the pieces you are seeking to learn over and over again until you can hear them perfectly in your mind. When you are watching someone play observe their technique and it will give you clues about how to use your body when you play. Consider what types of motions correspond with the sounds you hear. Consider also that your body is part of the instrument. After all, the instrument can't do anything without you playing it so how you use your body while playing makes a difference.

1. Learn 2. Practice 3. Play

- **Learning, Practicing, and Playing.** These are the three basic stages of accomplishing music. Each is a unique experience. The better one becomes at each stage, the faster it becomes to get to the playing stage with songs.

 The Learning stage is where the student should be most meticulous to detail. Play through the song slowly. If needed, just play the pitches in order without worrying about the rhythmic notation. It is also useful to eliminate the pitches and just play through the rhythmic notation on the open A string. If the song is not very familiar to you, listen to the recording of it repeatedly. Once you can hear the song in your head, it becomes much easier to make it come out of your instrument.

 The Practicing stage begins when the song is familiar enough to you that you can play it from memory, or sight-read it on tablature or standard notation. At the bare minimum play through every song you practice two times. The more times you play through a song correctly the better you will become at playing the song. Playing through the song more than once also helps you work on repeating from the end of the song back to the beginning of the song.

 The Playing stage is where we all strive to be. Once you have learned and practiced a song sufficiently you should begin to play through it as you interpret, from beginning to end. Always avoid stopping and starting over when you are playing a song. Playing songs with others is an open field. There are many styles of music and tastes that people pursue. Music is a social art form. Music can be played for listeners, dancers, theatre productions, commercials, TV shows and movies, ceremonies, etc.

 Please also understand that when we play music we are not following rules. We are applying **principals**. A rule states that "thou shalt" whereas a principal connotates "if you do this in this fashion you typically get this result."

 Performing I consider an optional fourth stage of music. It is not necessary that everyone strive to be a performer. Playing music for mere enjoyment is enough. Performing adds the element of the audience, which makes the playing of every song a new experience for the performer.

Tuning the Violin:

▷VIDEO *(This is the 1st video in the youtube.com, Jamalongseries, Fiddle Book 2 playlist)*

The first video on youtube.com for Fiddle, Book 2 will be a simple tuning video.
If you have access to a computer there are numerous online tuners that work well also.

When you tune an instrument you want to have a means of referencing the note you are tuning to. <u>If you require tape on the fingerboard I strongly recommend you begin with Jam Along Series, Fiddle Book 1</u> before this book.

Sometimes we tune to another musician we are playing with, or every musician tunes to a tuning fork, pitch pipe, electronic tuner, or other tuning device.

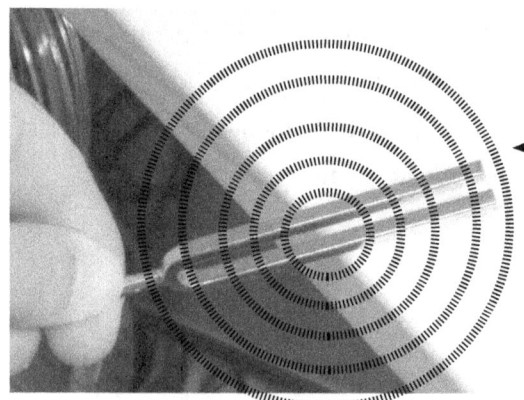

When you use a tuning fork, strike it against a hard surface. This way the arms of the fork will vibrate. Make sure not to mute the arms of the tuning fork with the hand you are holding it with.

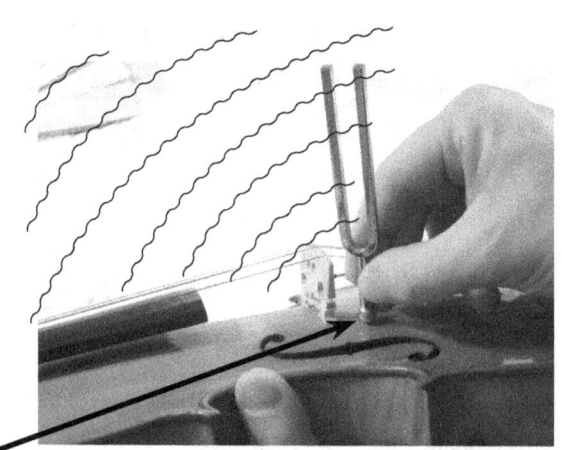

Now place the fork on the top of the instrument on the left side ("bass bar side") of the bridge. Tune your A string to the note you hear the tuning fork create. Now you can tune all of the other open strings by bowing double stops on the pairs to tune the fifth.

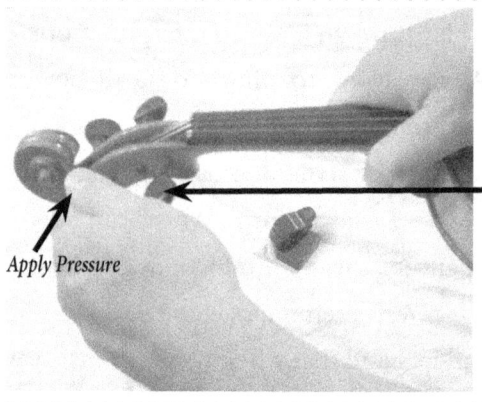

Apply Pressure

Use the peg box tuners if the note needs to be changed more than a half-step.
(Remember to apply some pressure inward toward the pegbox as you turn the tuning pegs. This helps keep the pegs set in the pegbox.)
— *Peg Box Tuners*

Use the fine tuners in the tailpiece when the note is within a half-step.

Fine Tuners

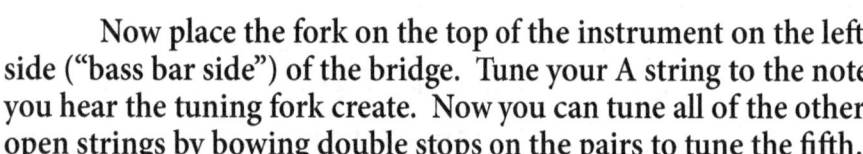

There are many types of electronic tuners. Some affix to the instrument like the one pictured. Other use a microphone or a chord with a clamp to read the note. Some of these tuners use arrows and others use a needle to show whether the note is sharp or flat. Experiment with different types of electronic tuners so see which kind you like best.

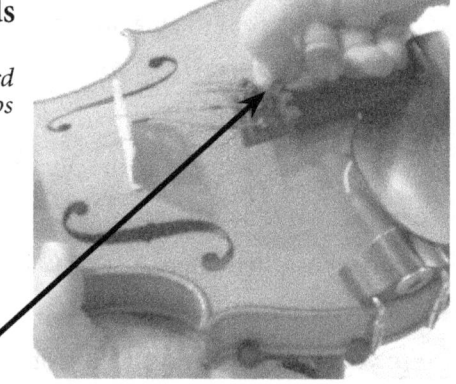

Electronic Tuner

The Musical Alphabet/Cromatic Scale

The musical alphabet consists of 7 different natural notes represented by the letters: **A B C D E F G**. After the note G it goes back to A an octave (eight notes) higher than where it started. This is also true of the opposite direction:

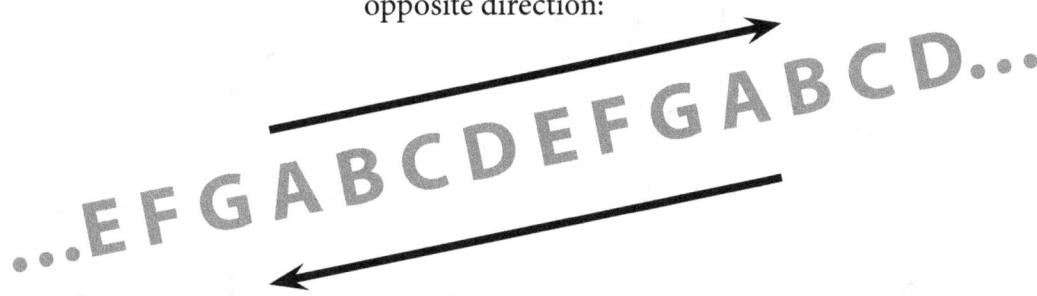

But in addition to these seven natural notes, there are five more notes that each have two names:

The "#" symbol is called a "sharp" and it raises a note by ½ step.

A# C# D# F# G#
or
Bb Db Eb Gb Ab

The "b" symbol is called a "flat" and it lowers a note by ½ step.

For now we can consider these names interchangeable. Therefore, A# and Bb are the same note; and so are C# and Db, D# and Eb, F# and Gb, and finally G# and Ab. When we put all of these notes together we get the <u>Chromatic Scale</u>:

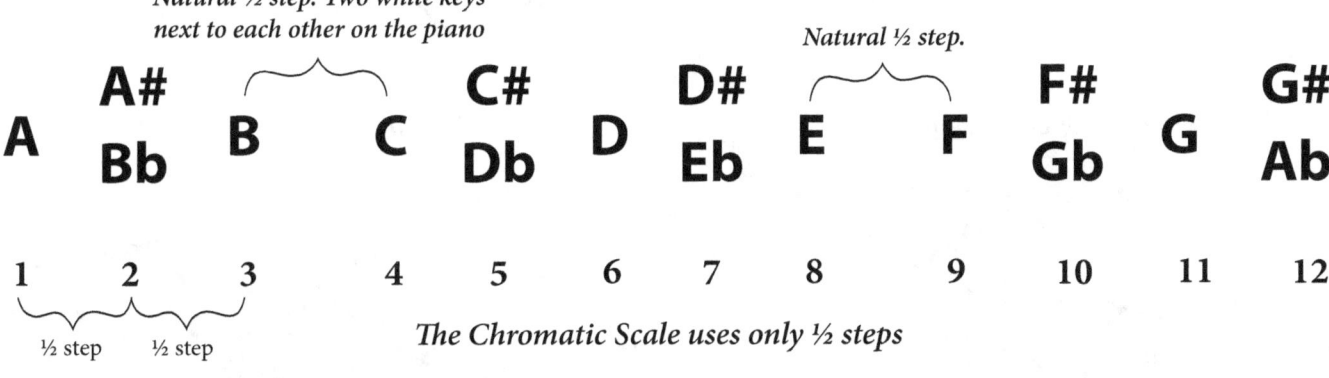

The Chromatic Scale uses only ½ steps

In the pages that follow, we will be dealing with any of the 12 notes from the chromatic scale when playing our exercises and melodies.

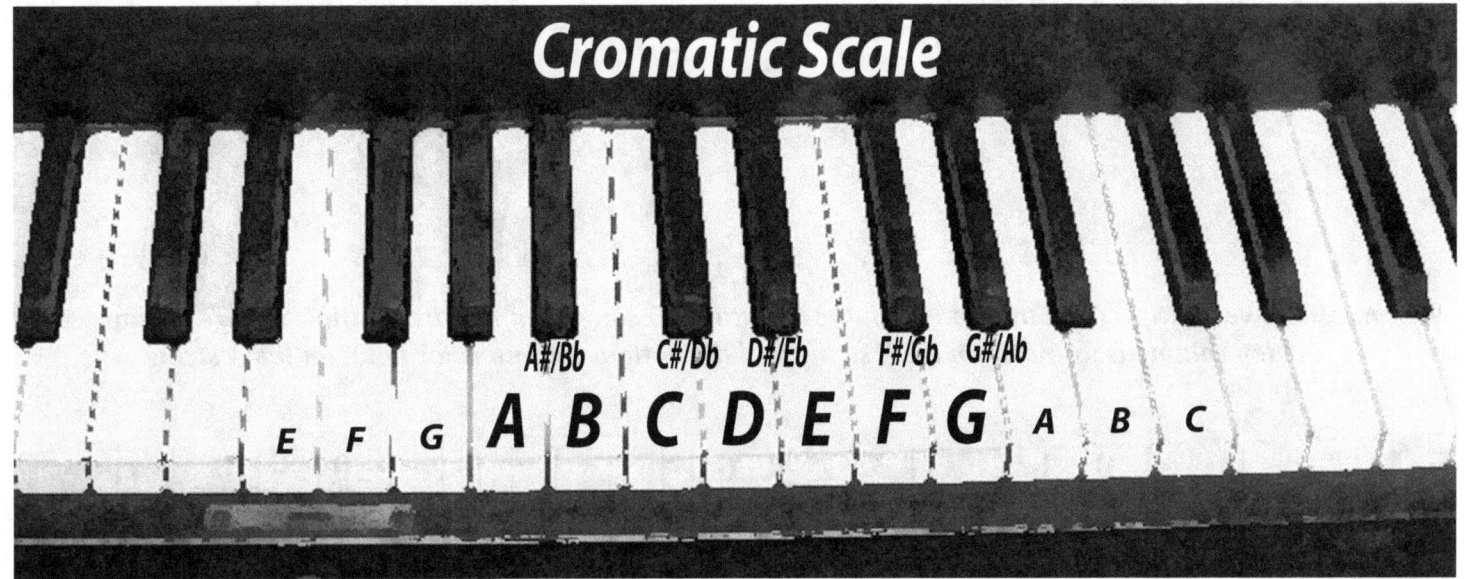

FIDDLE: BOOK ONE

Reading Tablature

Tablature is a means of notating strings and finger placement on the neck of the violin. Music in standard notation for all songs and exercises will appear later in the book.

TAB:

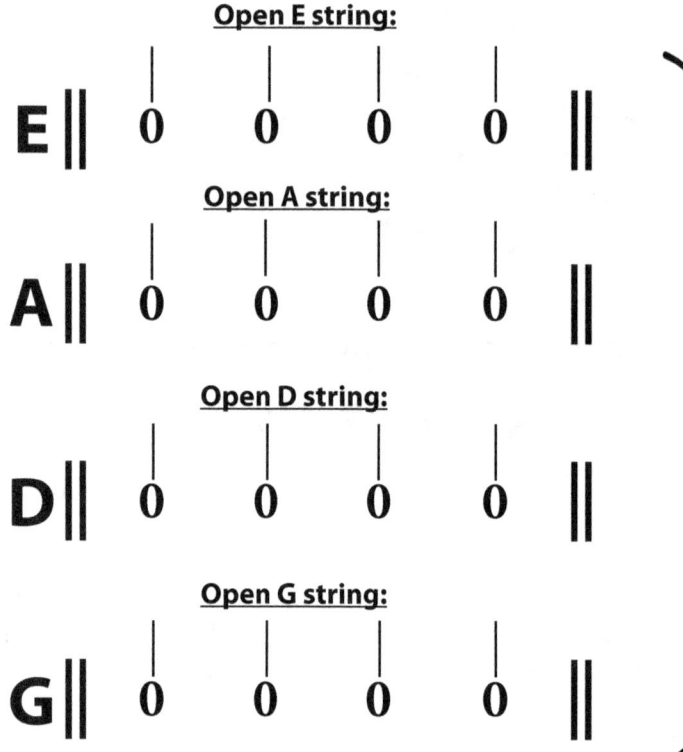

- Each of these represents one measure of tablature.

- There are four zeroes in each measure which represents the open string being played four times.

- Each zero has a stem above it. Consider this the same as a quarter note stem which shows the note lasts one beat.

Bowing The Open E String:

Bowing The Open A String:

Bowing The Open D String:

Bowing The Open G String:

We can also have multiple columns notated in the tablature for songs that require multiple strings. Below we see the top column is for notes on the E string and the bottom column is for notes on the A string.

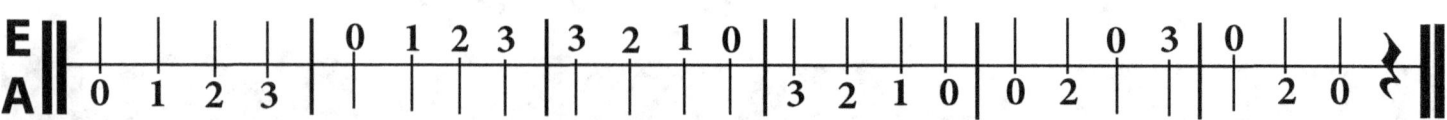

12 FIDDLE: BOOK ONE

The Third Finger/Shape 1:

Here is a diagram of Shape 1 which we learned from Book 1. All the songs and exercises in this book will be using shape 1. The first finger will always be a whole step away from the open string, the second finger will always be a two whole steps from the open string and the third finger will always be two whole steps and a half step away from the open string. This shape will apply consistantly to all four strings

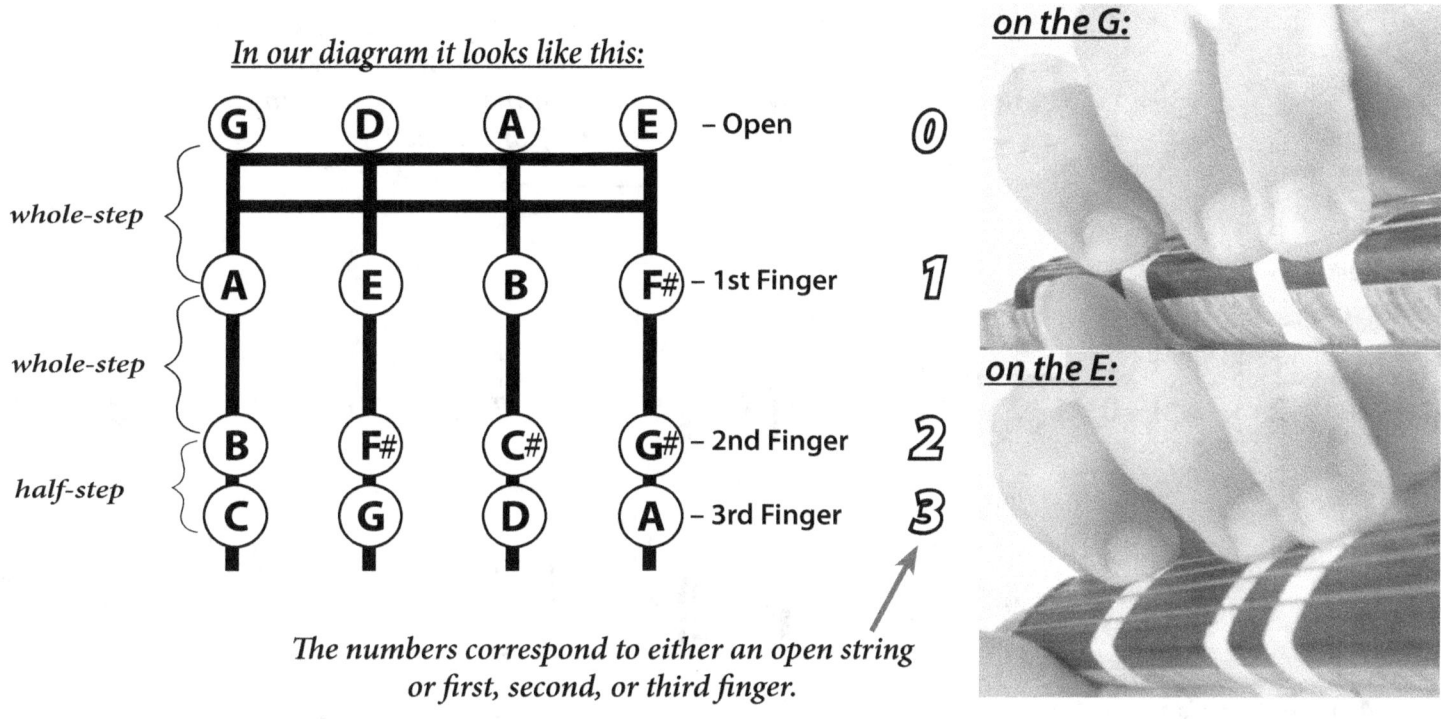

On the following page we will be playing shape 1 in four single string exercises. Below is a series of pictures to illustrate the progression of finger placement that properly renders shape 1. You will notice that there is tape on the fingerboard in these pictures. If you wish to tape the fingerboard I recommend the section of how to tape the fingerboard in Book 1.

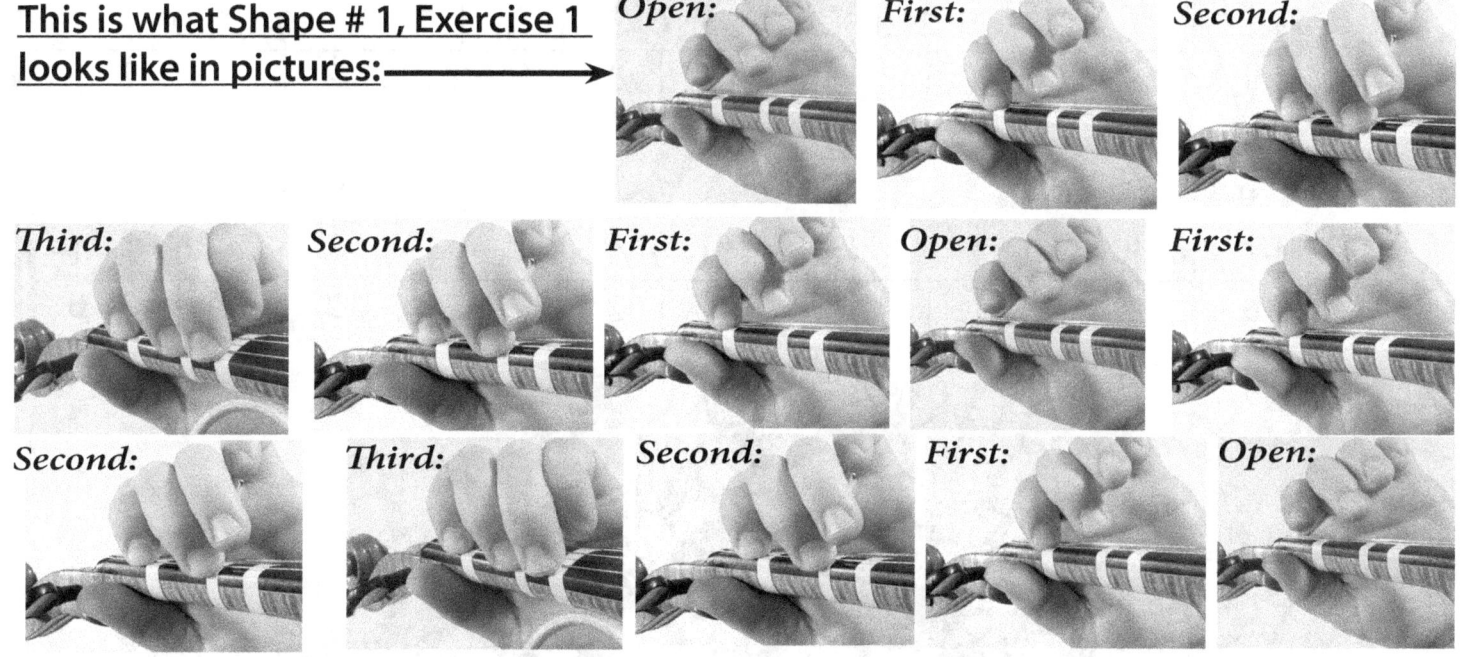

FIDDLE: BOOK ONE

Warm-Up Page

 (This is the 2nd video in the youtube.com, Jamalongseries, Fiddle Book 2 playlist)

This is the "Warm-Up Page" from Book 1. In Book 1 we learned to play the open strings as well as the first, second, and third fingers in a configuration called Shape 1. If it is unclear to you how to do this i recommend reviewing finger placement and Shape 1 from Book 1.

Shape 1:

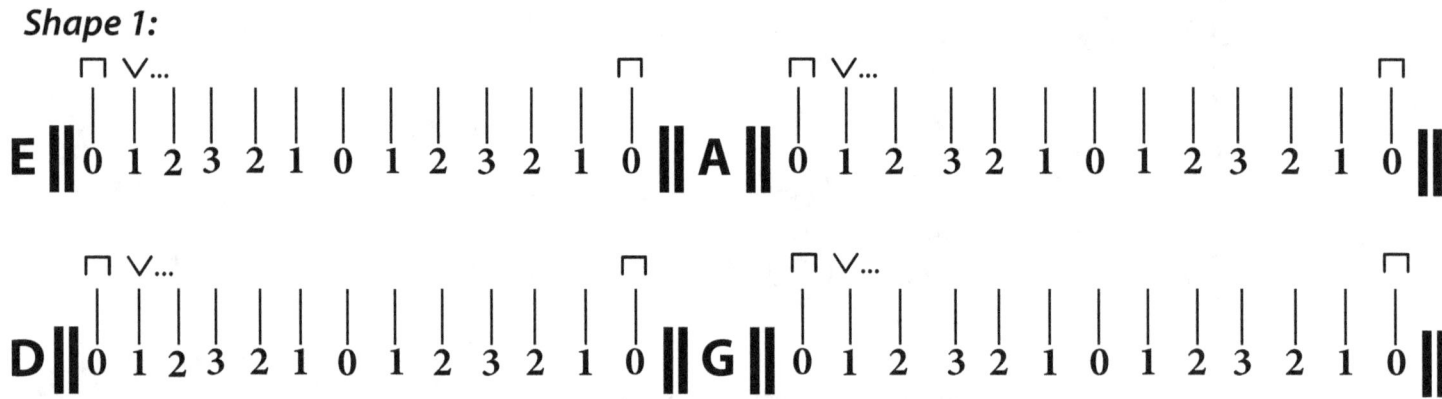

A major scale: *Arpeggio:*

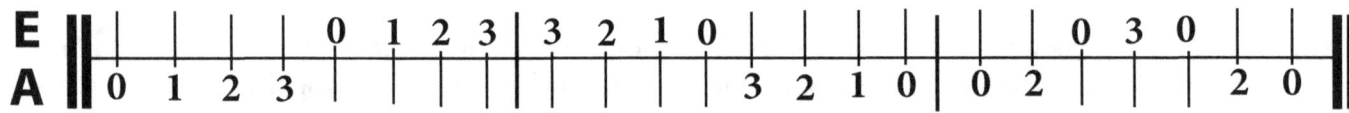

D major scale: *Arpeggio:*

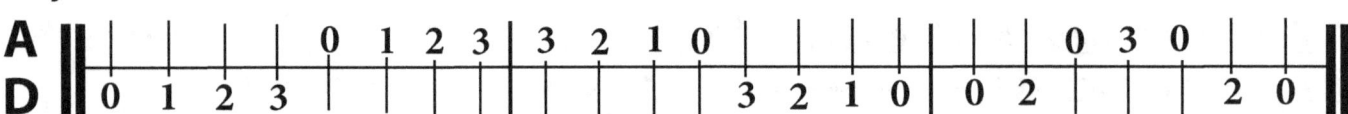

G major scale: *Arpeggio:*

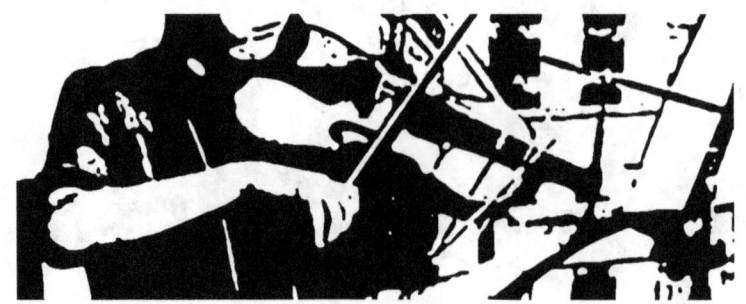

Major Scales And Arpeggios With Slurs

VIDEO *(This is the 3rd video in the youtube.com, Jamalongseries, Fiddle Book 2 playlist)*

We are going to learn about slurs here since many of the melodies we will learn in the book will use slurs. For the exercise below we will be slurring two notes per bow stroke.

Cripple Creek is a song with two melodies. The first melody we name "A" and the second melody we name "B." Both of these melodies use repeats which makes the form of the song AABB. Always follow this form when you play the song.

Cripple Creek (AABB)

(On the D, A and E strings/Key of A major)

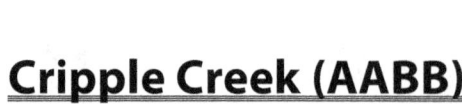 (This is the 4th video in the youtube.com, Jamalongseries, Fiddle Book 2 playlist)

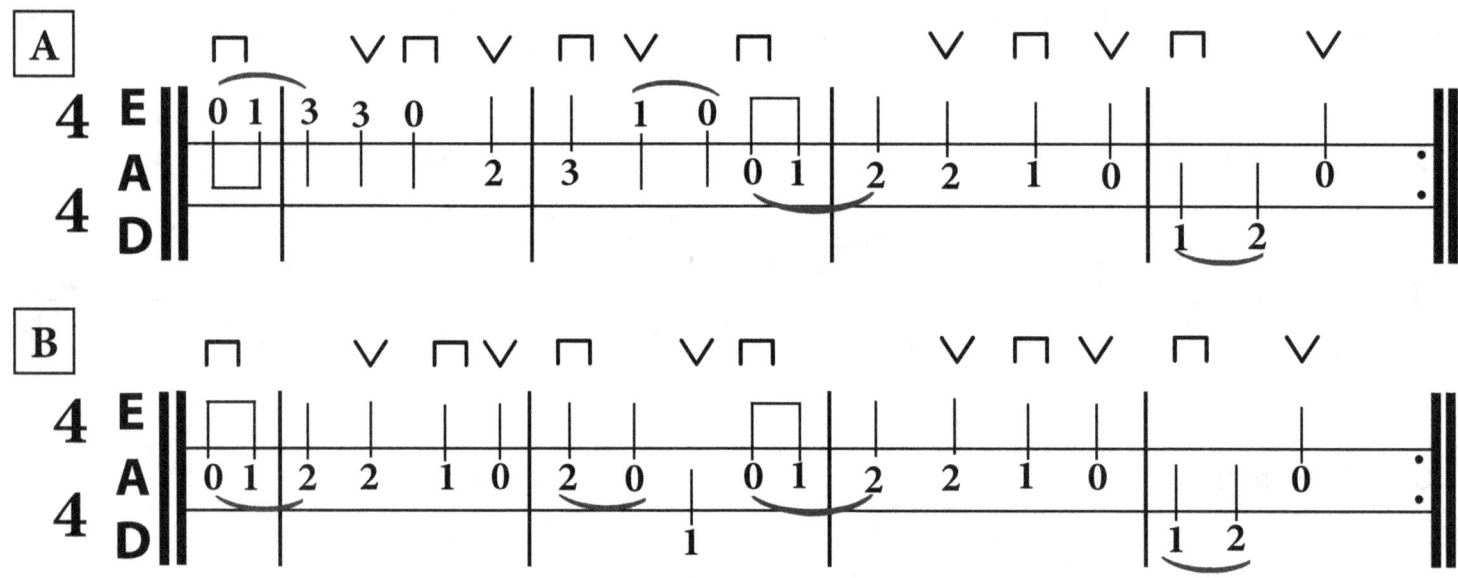

Whenever possible, play through each song at least two times. In situations where the song has an A melody and a B melody then play AABBAABB as two times through the song.

FIDDLE: BOOK ONE

Liza Jane:

(On the A and E strings/Key of A major)

▷VIDEO **(This is the 5th video in the <u>youtube.com, Jamalongseries, Fiddle Book 2</u> playlist)**

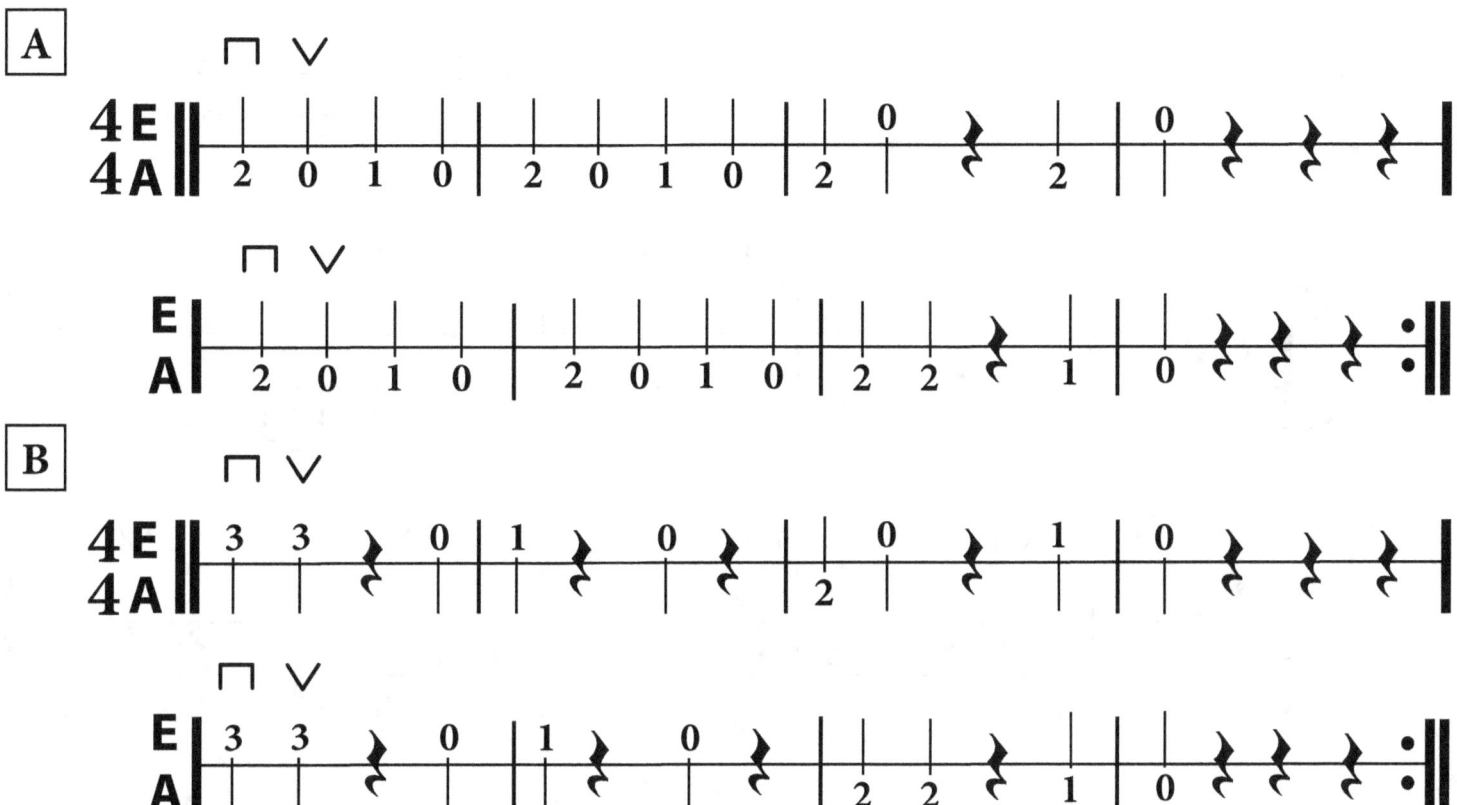

> In Book 1 we established that any melody using three strings or less can be transposed onto other sets of strings. Liza Jane is only using the A, and E strings which means it could also be played on the D, and A; as well as the G, and D. Doing this with melodies can be very useful.

FIDDLE: BOOK ONE

Wildwood Flower

(This is the 6th video in the youtube.com, Jamalongseries, Fiddle Book 2 playlist)

(On the D, A, and E strings/Key of D major)

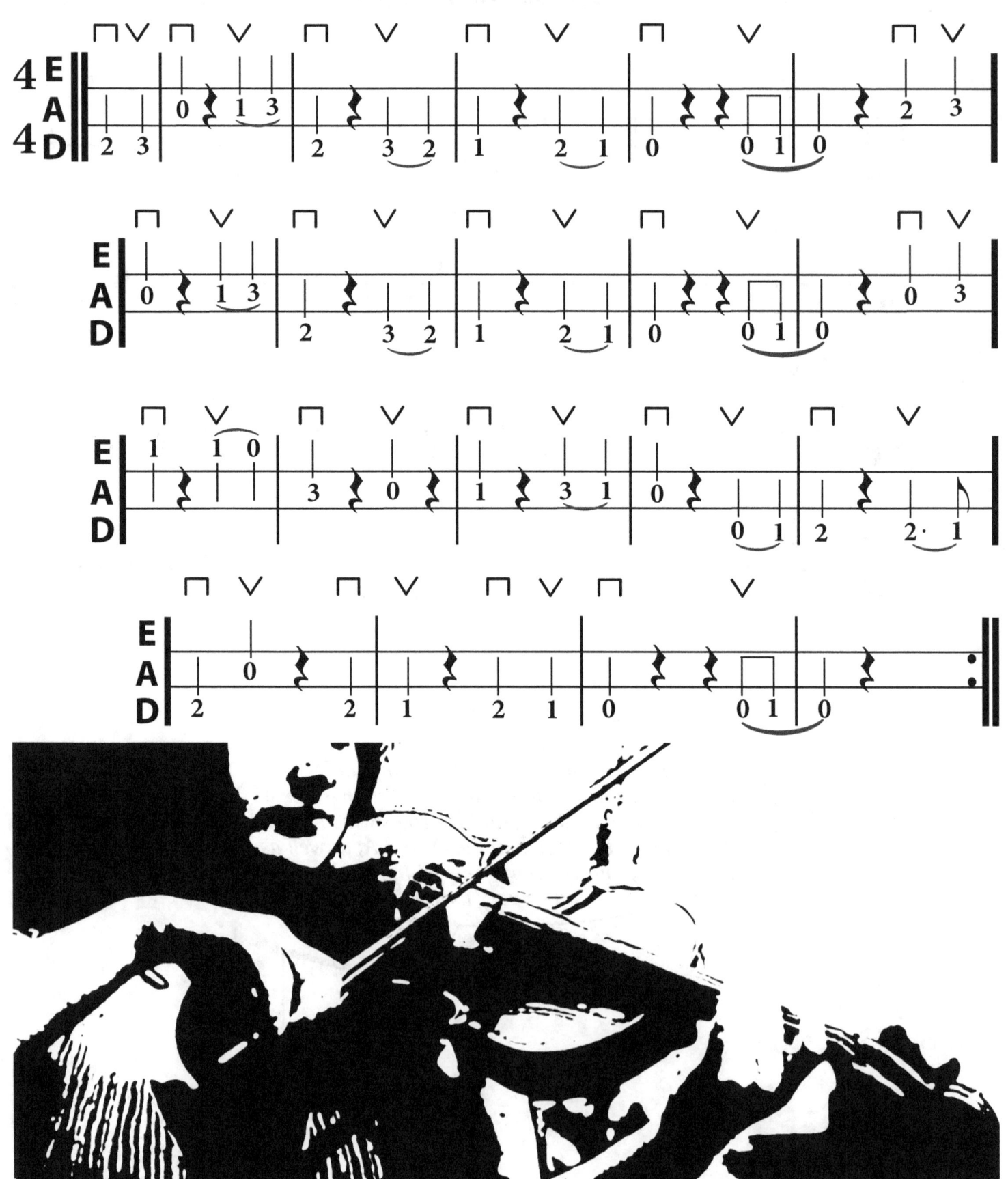

Dotted Rhythm Exercise:

▷VIDEO **(This is the 7th video in the youtube.com, Jamalongseries, Fiddle Book 2 playlist)**

In Oh Susanna we will have to play some "dotted" quarter notes. When a dot is added after a note, it adds half of the value of that note back to the note. Since a quarter note is worth one beat of time, the dot adds an eighth note worth of time to the quarter note. The dotted quarter note is now worth a beat and a half. The dotted quarter note will be followed by an eighth note on the off beat.

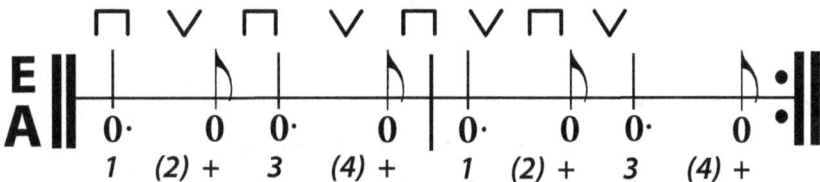

Oh Susanna --Stephen Foster

▷VIDEO **(This is the 8th video in the youtube.com, Jamalongseries, Fiddle Book 2 playlist)**

(On the A and E strings/Key of A major)

FIDDLE: BOOK ONE 19

3/4 Time:

Songs in 3/4 time have three beats per measure.
A waltz is a kind of song that uses 3/4 time.
One measure of 3/4 time looks like this rhythemically

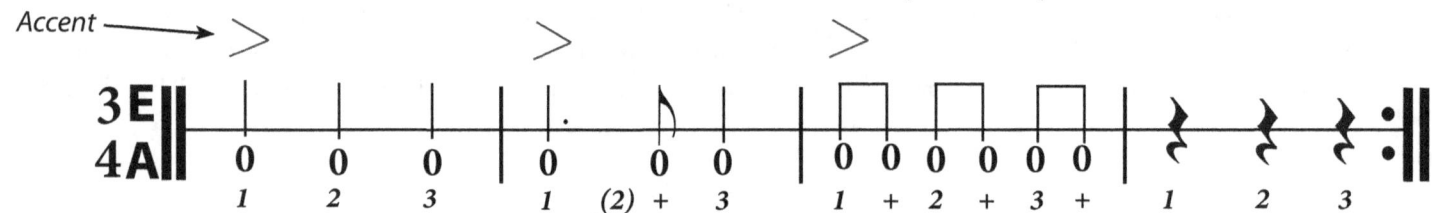

Often the first beat of a song in 3/4 time is accented and given more emphasis than beats two and three.

Amazing Grace

▷ VIDEO *(This is the 9th video in the youtube.com, Jamalongseries, Fiddle Book 2 playlist)*

(On the D, A and E strings/Key of A)

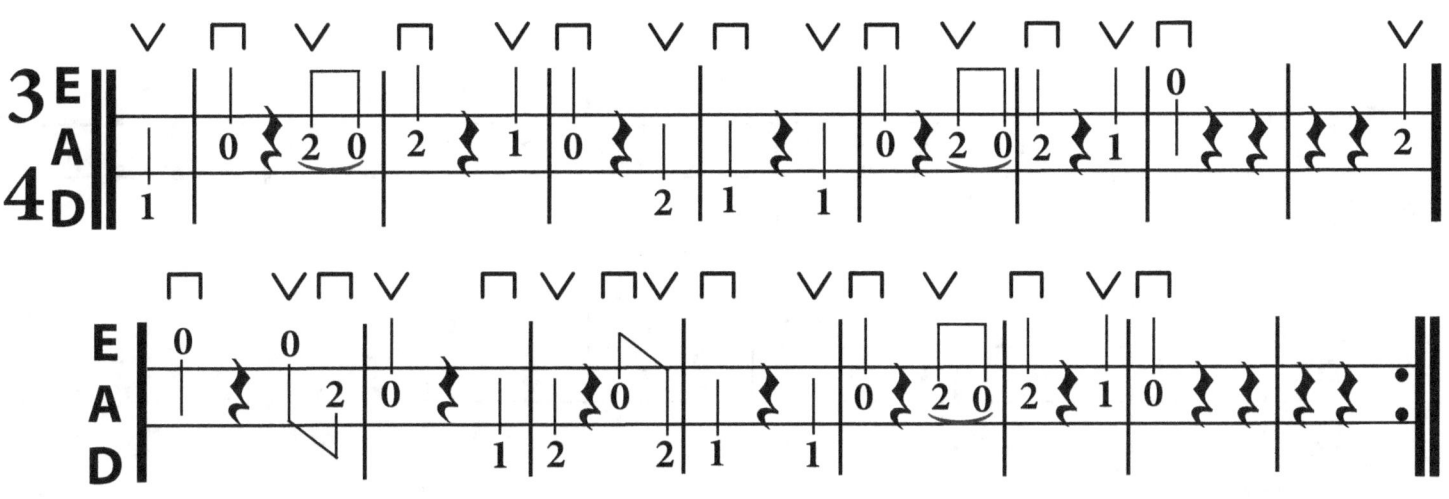

Amazing Grace

▷ VIDEO *(This is the 10th video in the youtube.com, Jamalongseries, Fiddle Book 2 playlist)*

(On the A and E strings/Key of D)

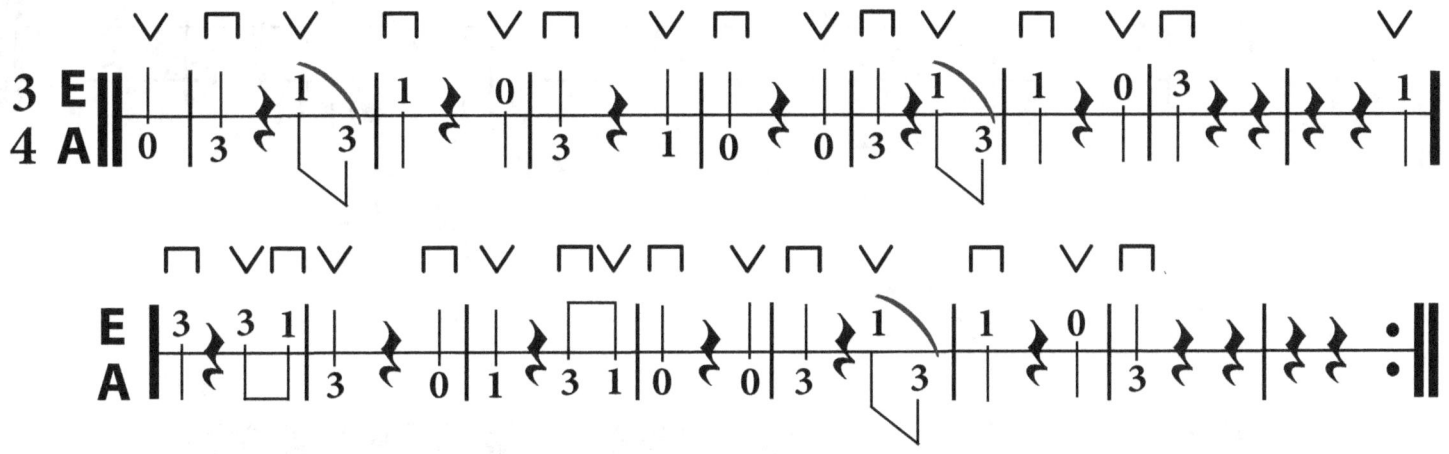

Down In The Willow Garden

(On the D, A and E strings/Key of G)

▷VIDEO **(This is the 11th video in the youtube.com, Jamalongseries, Fiddle Book 2 playlist)**

FIDDLE: BOOK ONE

Sally Goodin

(On the D, A, and E strings/Key of A major)

▷ VIDEO *(This is the 12th video in the youtube.com, Jamalongseries, Fiddle Book 2 playlist)*

A

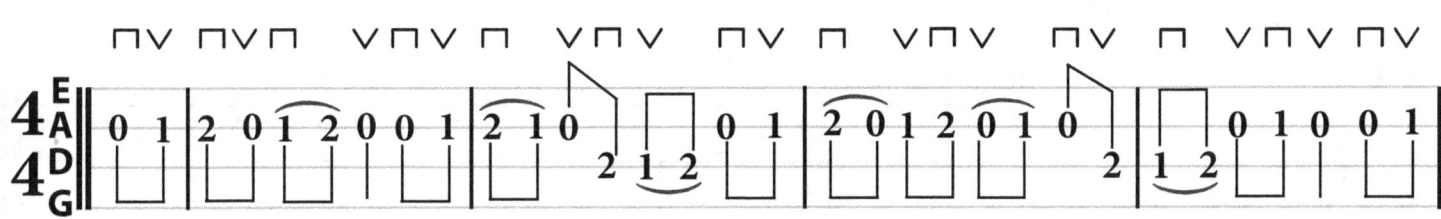

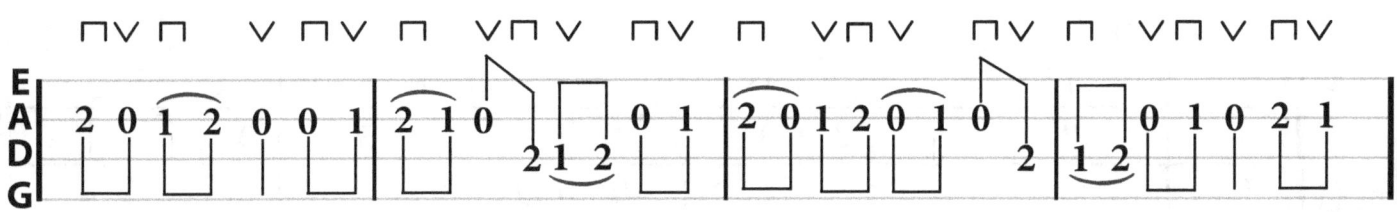

B

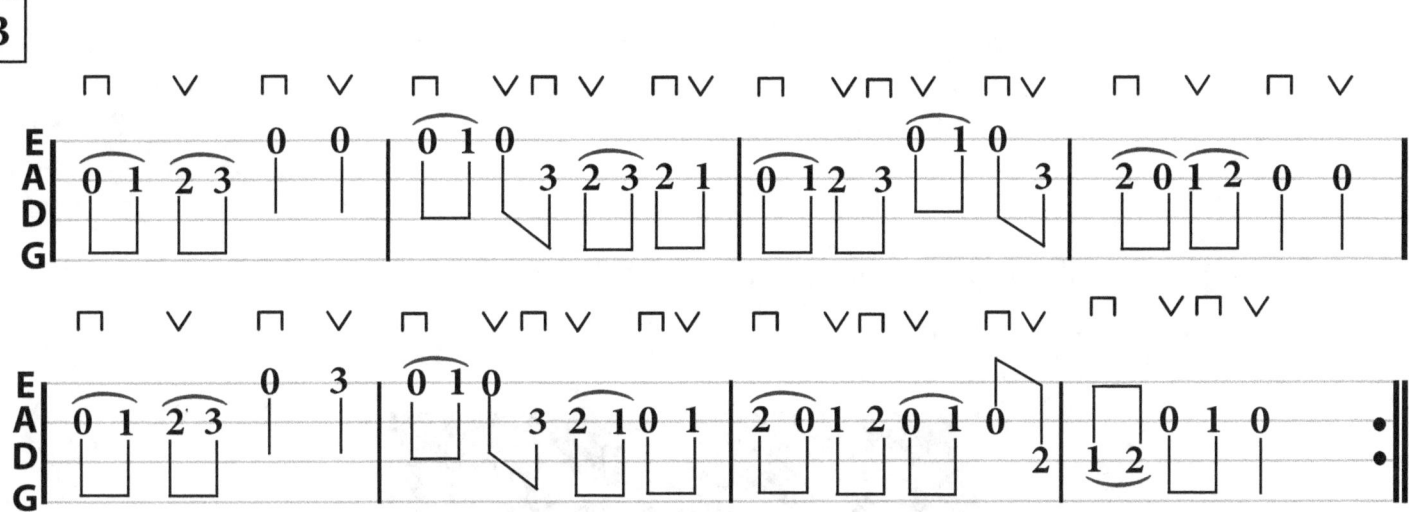

(Repeat, Back To The Beginning of the A part)

FIDDLE: BOOK ONE 23

8th of January

(On the D, A, and E strings/Key of D major)

VIDEO **(This is the 13th video in the youtube.com, Jamalongseries, Fiddle Book 2 playlist)**

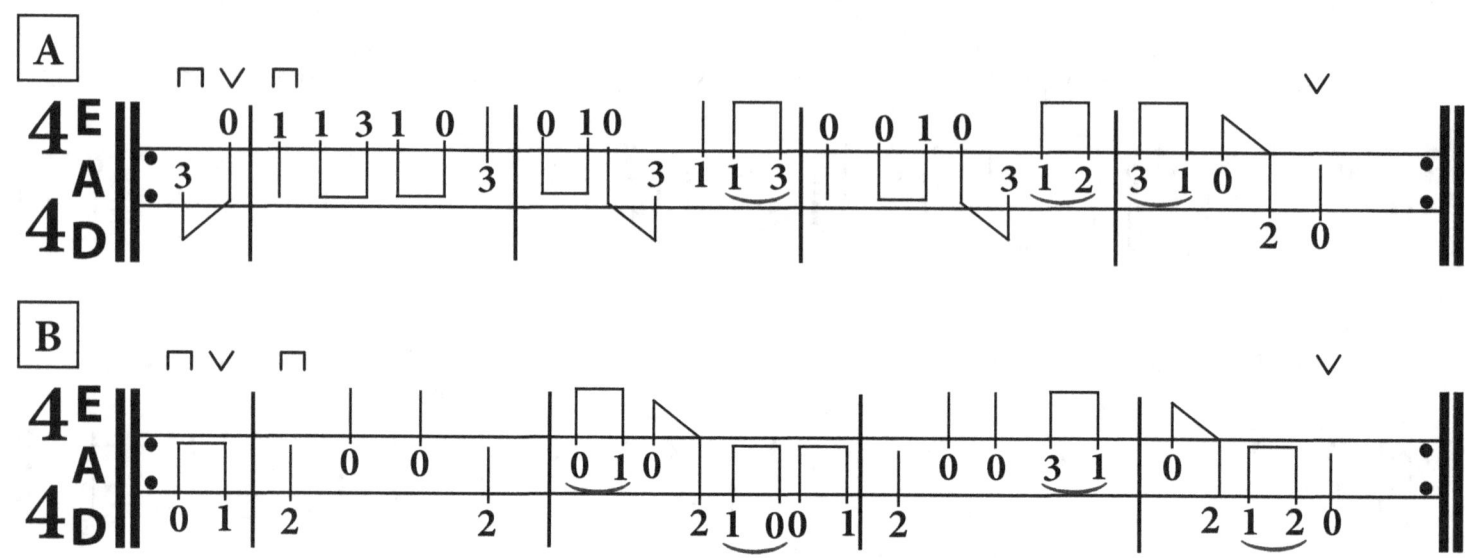

Shortnin Bread

(On the A and E strings/Key of A major)

▷ VIDEO *(This is the 14th video in the youtube.com, Jamalongseries, Fiddle Book 2 playlist)*

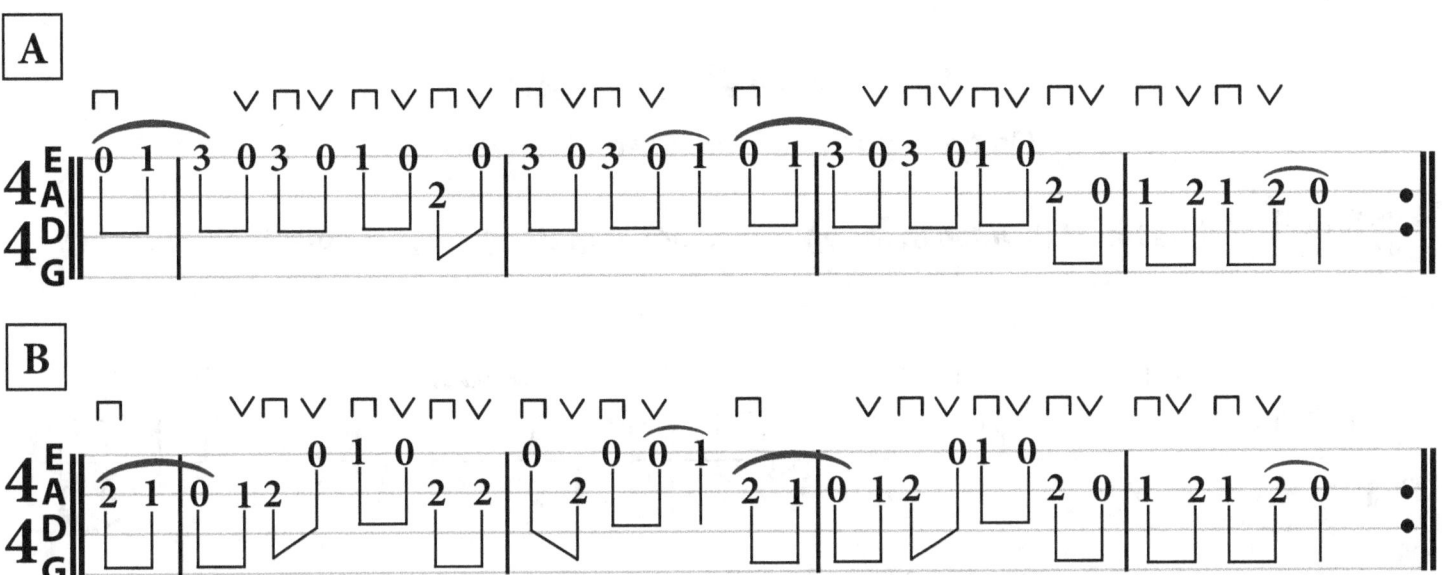

This is a version of boil the cabbage using two melodies. The song is played in the form AABB. Also Some slurs have been added. The first and second phrases of the A section and the second phrase of the B section use the down-bowing pattern of three notes on a down bow are the start of the phrase.

Boil The Cabbage (AABB)

(On the A and E strings/Key of A major)

▷VIDEO **(This is the 15th video in the youtube.com, Jamalongseries, Fiddle Book 2 playlist)**

26 FIDDLE: BOOK ONE

6/8 Time:

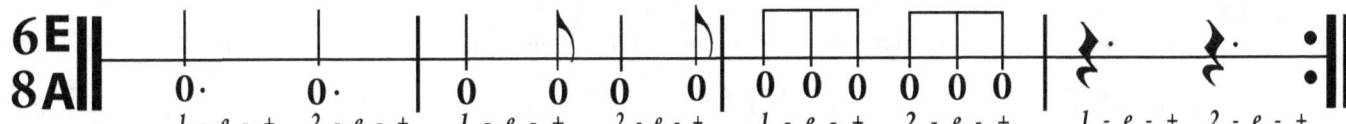(**This is the 16th video in the youtube.com, Jamalongseries, Fiddle Book 2 playlist**)

Songs in 6/8 time have six eighth note beats per measure.
When a song is written in 6/8 time the time signature changes in the staff.
The underlyinig grid we count for every measure is 1e+, 2e+.
Notice that the quarter notes and the quarter rests have dots following them.
The dot adds an eighth note to the quarter note so it last all three sub-beats of the triplet.

In this book there is only one song in 6/8 time which is Swallowtail Jig notated below and in the music reference section. Book 1 contained Row Row Row Your Boat which is also in 6/8 time. Book 3 will have more songs in this time signature as well.

Swallowtail Jig

(On the D, A and E strings/Key of E Dorian minor)

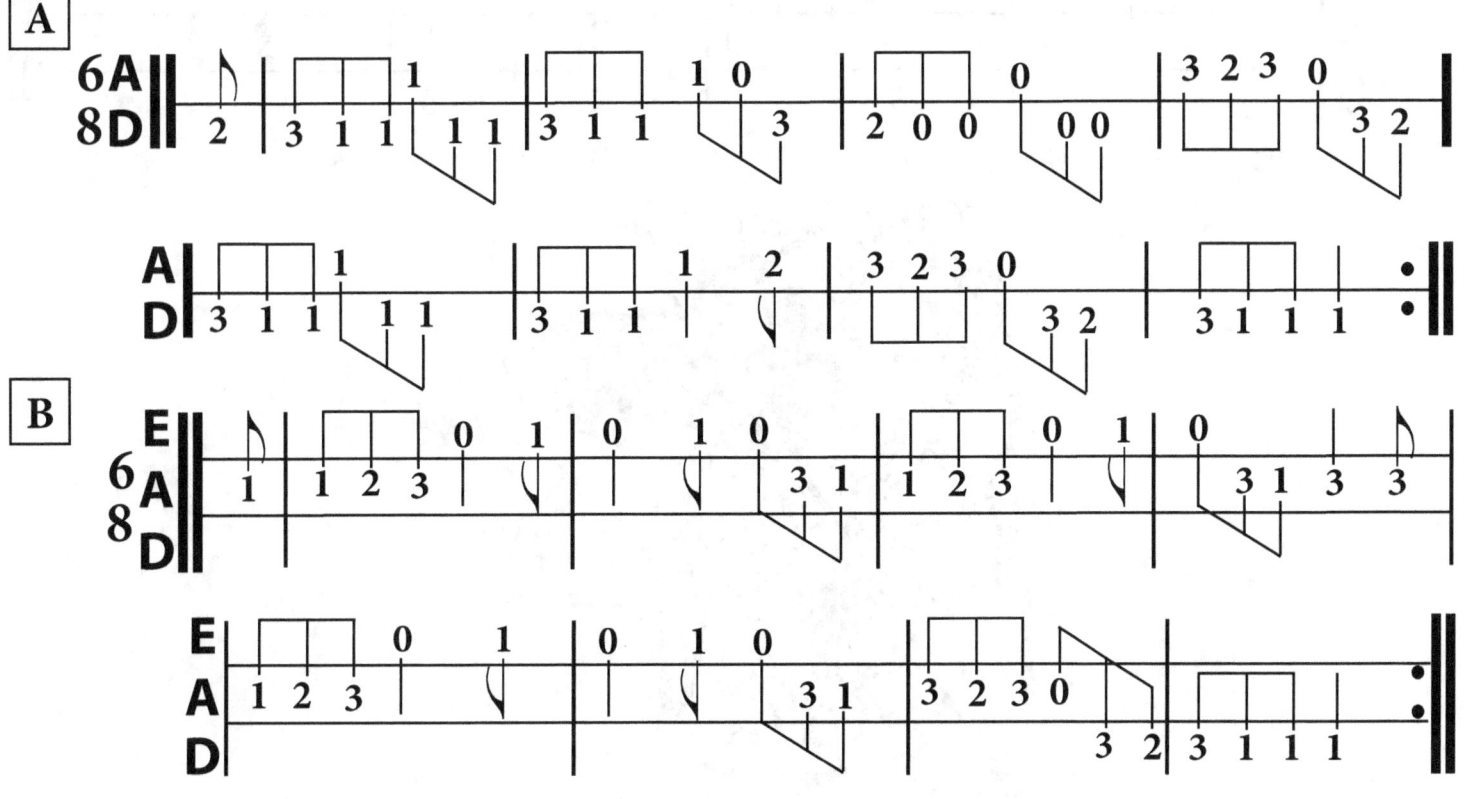

FIDDLE: BOOK ONE 27

Auld Lange Syne:
(On the D, A and E strings/Key of G major)

▷ VIDEO **(This is the 17th video in the youtube.com, Jamalongseries, Fiddle Book 2 playlist)**

verse

Should old ac-quain-tence be for-got and ne-ver brought to mind, should

old ac-quain-tence be for-got and au - ld la - nge syne. For

chorus

au - ld la - nge zyne my dear for au - ld la - nge syne, we'll

raise a cup of kind-ness yet for au - ld la - nge syne.

28 FIDDLE: BOOK ONE

Angelina Baker:
(On the A and E strings/Key of D major)

▷VIDEO (This is the 18th video in the youtube.com, Jamalongseries, Fiddle Book 2 playlist)

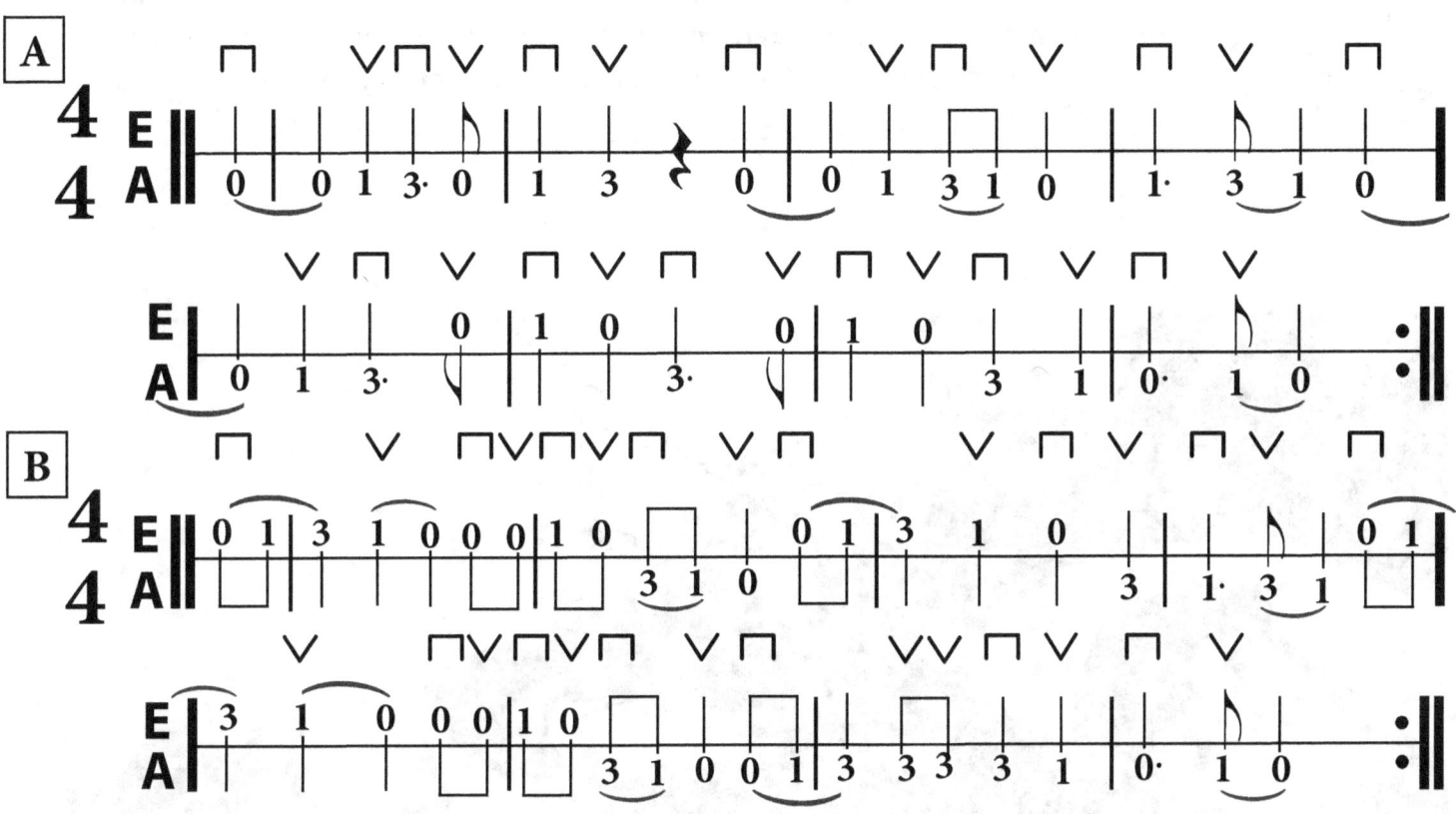

> To the right is a Repertoire List of all the songs we have covered in this book. If you add these to what is covered in Book 1 we will have a total of 26 songs. I recommend memorizing these songs and becoming able to play them from memory.

Repertoire List

1 Cripple Creek
2 Liza Jane
3 Wildwood Flower
4 Oh Susanna
5 Amazing Grace
6 Down In The Willow Garden
7 Sally Goodin
8 8th of Jan.
9 Shortnin Bread
10 Boil The Cabbage
11 Swallowtail Jig
12 Auld Lange Syne
13 Angelina Baker

FIDDLE: BOOK ONE 29

Music Reference

This section features the music in standard notation of all the songs we have covered in tablature in this book. For some of these beginning exercises and songs I have left out the time and key signatures to help the notation look more straight forward.

Reading tablature is perfectly fine, especially if it is assisting you as a good learning tool. However, please be aware that learning to read music in standard notation will give you access to a much larger world of available musical information since far more violin/fiddle music is written in the standard notation format.

Warm-Up Exercise

▷ VIDEO *(This is the 2nd video in the youtube.com, Jamalongseries, Fiddle Book 2 playlist)*

Shape #1/Exercise 1 (E, A, D, and G)

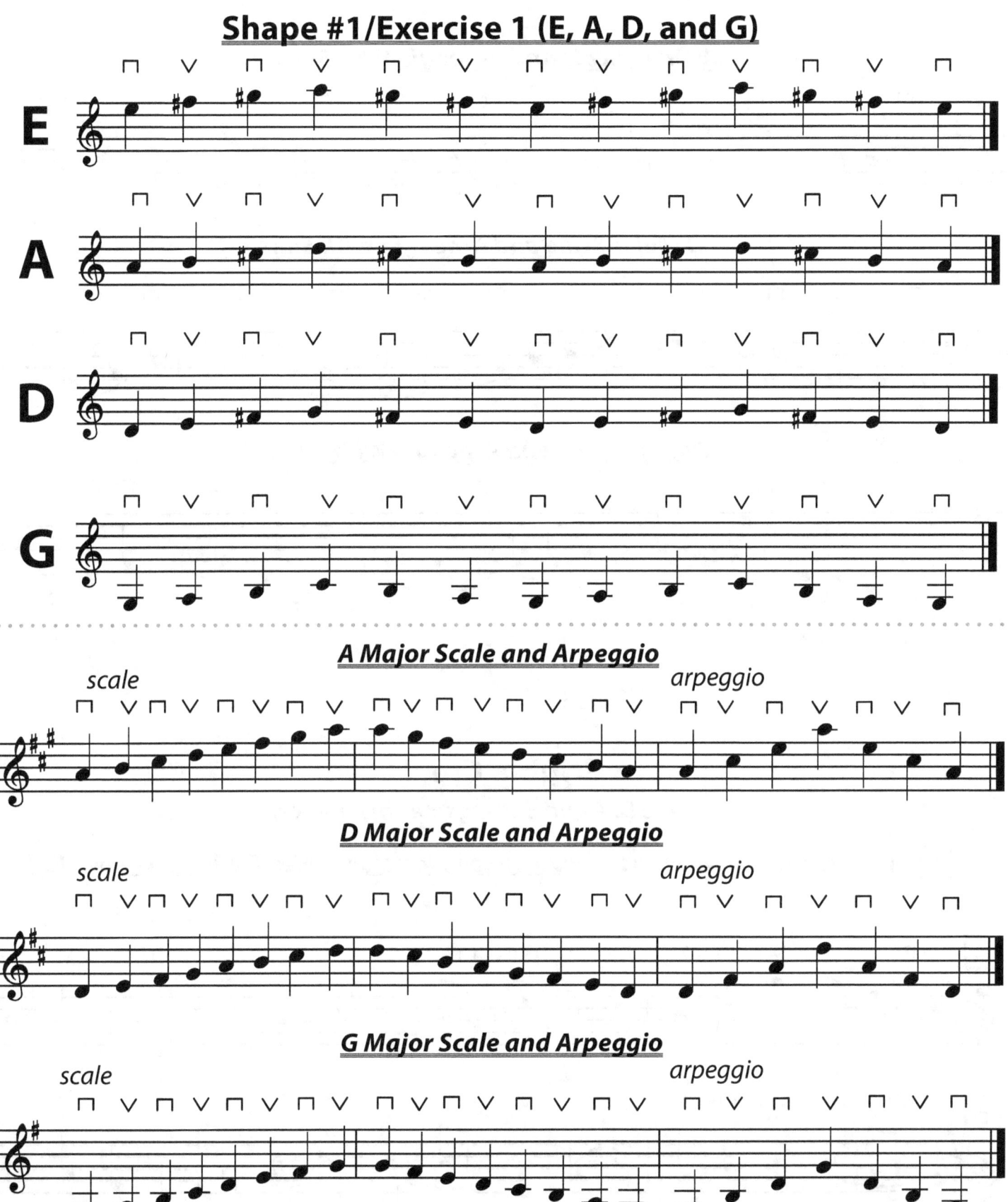

Scales And Arpeggio's With Slurs

▷VIDEO **(This is the 3rd video in the youtube.com, Jamalongseries, Fiddle Book 2 playlist)**

A Major Scale and Arpeggio With Slurs

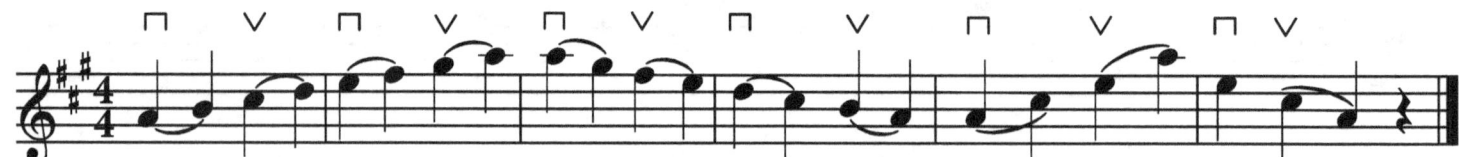

D Major Scale and Arpeggio With Slurs

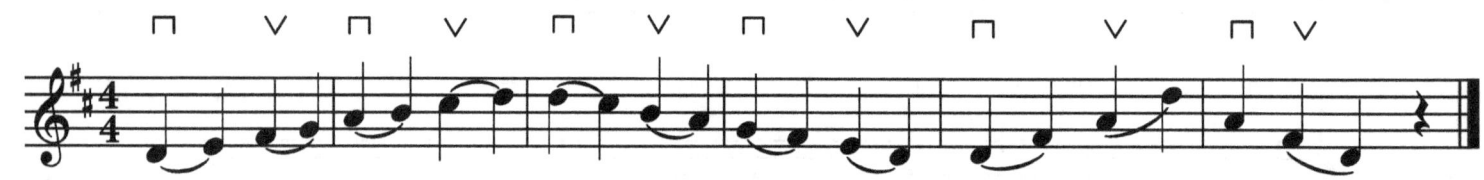

G Major Scale and Arpeggio With Slurs

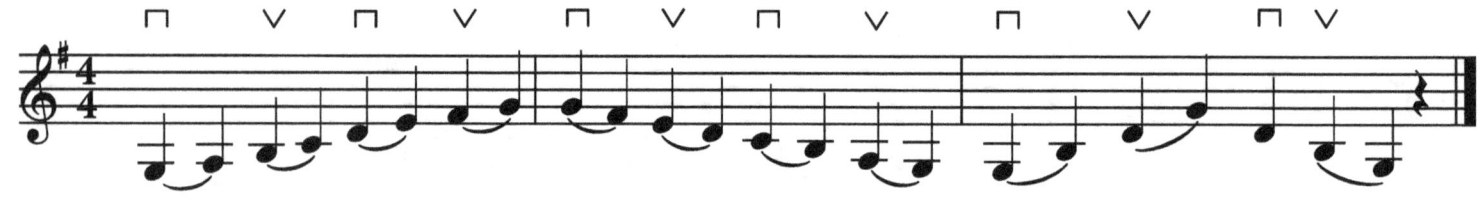

Cripple Creek
(On the D, A and E strings/Key of A major)

▷VIDEO **(This is the 4th video in the youtube.com, Jamalongseries, Fiddle Book 2 playlist)**

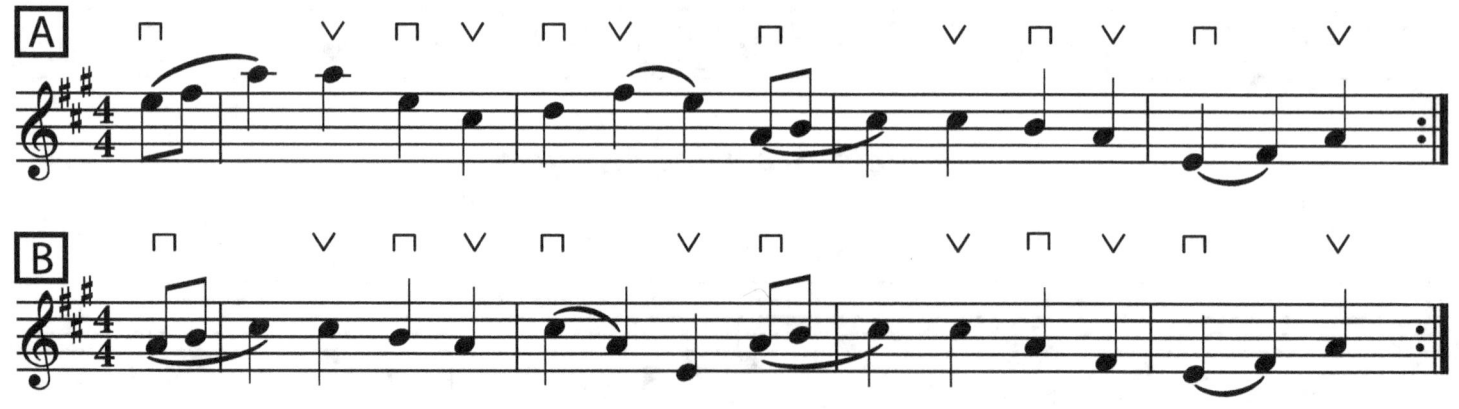

Liza Jane
(On the A and E strings/Key of A major)

▷VIDEO **(This is the 5th video in the youtube.com, Jamalongseries, Fiddle Book 2 playlist)**

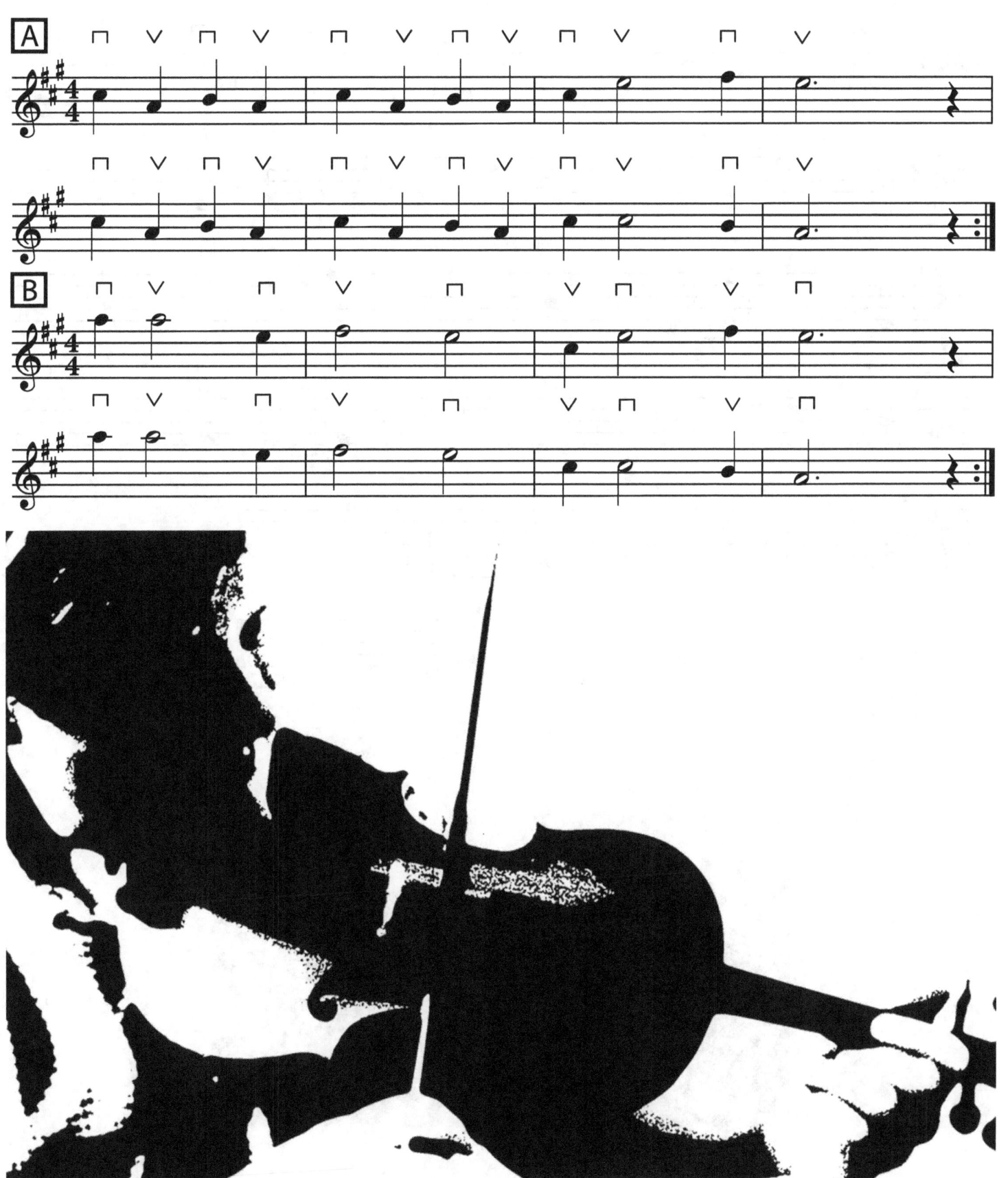

Wildwood Flower

(On the D, A and E strings/Key of D major)

▷VIDEO *(This is the 6th video in the youtube.com, Jamalongseries, Fiddle Book 2 playlist)*

--End

FIDDLE: BOOK ONE

Oh Susanna
(On the A and E strings/Key of A major)

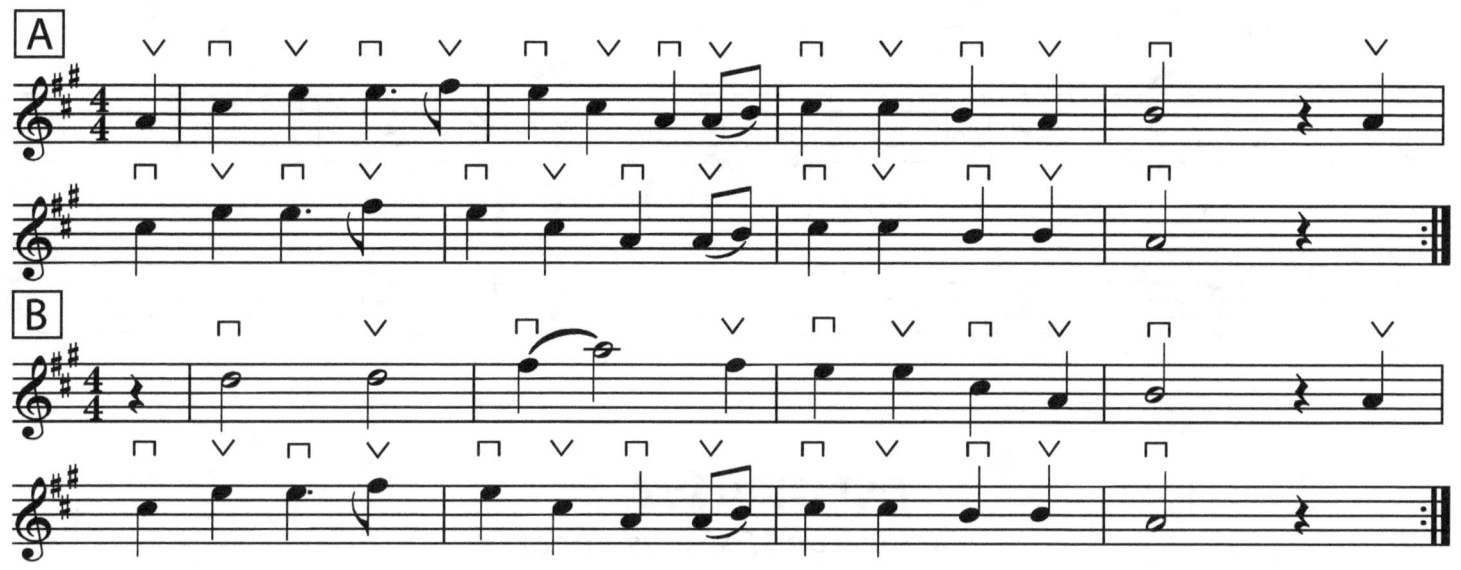

(This is the 8th video in the youtube.com, Jamalongseries, Fiddle Book 2 playlist)

Amazing Grace
traditional melody

(On the D, A and E strings/Key of A)

▷VIDEO **(This is the 9th video in the <u>youtube.com, Jamalongseries, Fiddle Book 2</u> playlist)**

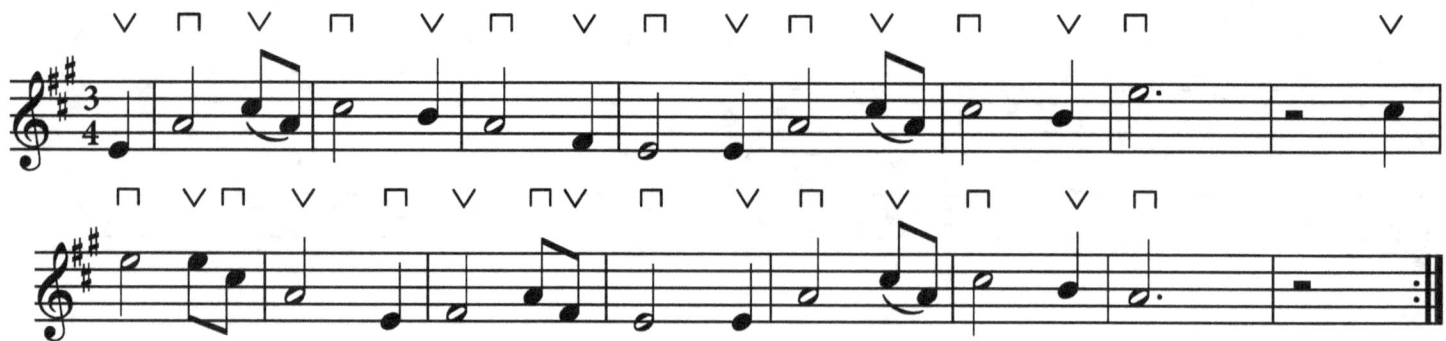

Amazing Grace

(On the A and E strings/Key of D)

▷VIDEO **(This is the 10th video in the <u>youtube.com, Jamalongseries, Fiddle Book 2</u> playlist)**

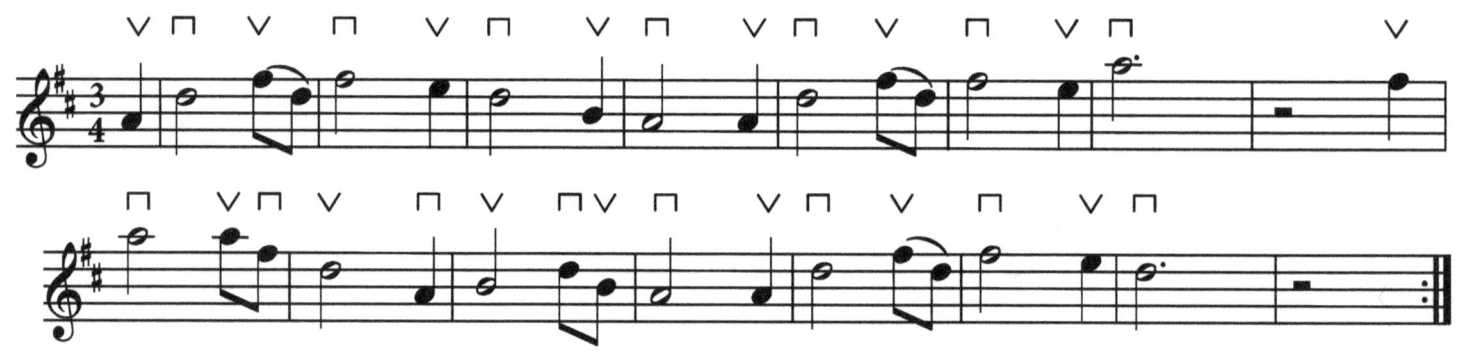

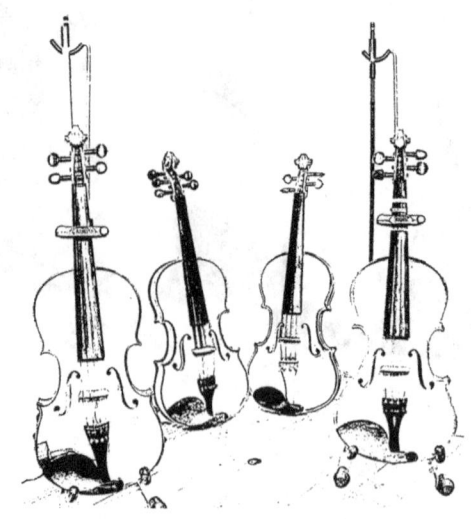

Down In The Willow Garden

(On the D, A and E strings/Key of G)

(This is the 11th video in the youtube.com, Jamalongseries, Fiddle Book 2 playlist)

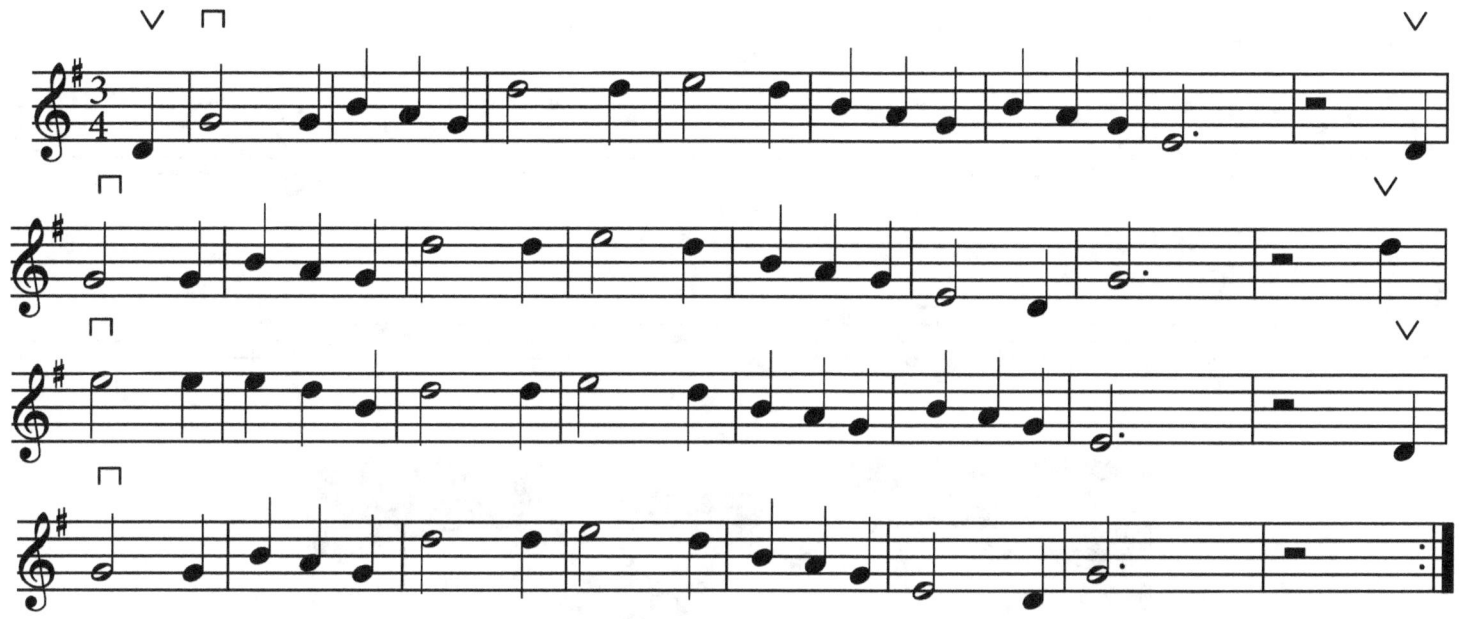

Sally Goodin

(On the D, A and E strings/Key of A)

(This is the 12th video in the youtube.com, Jamalongseries, Fiddle Book 2 playlist)

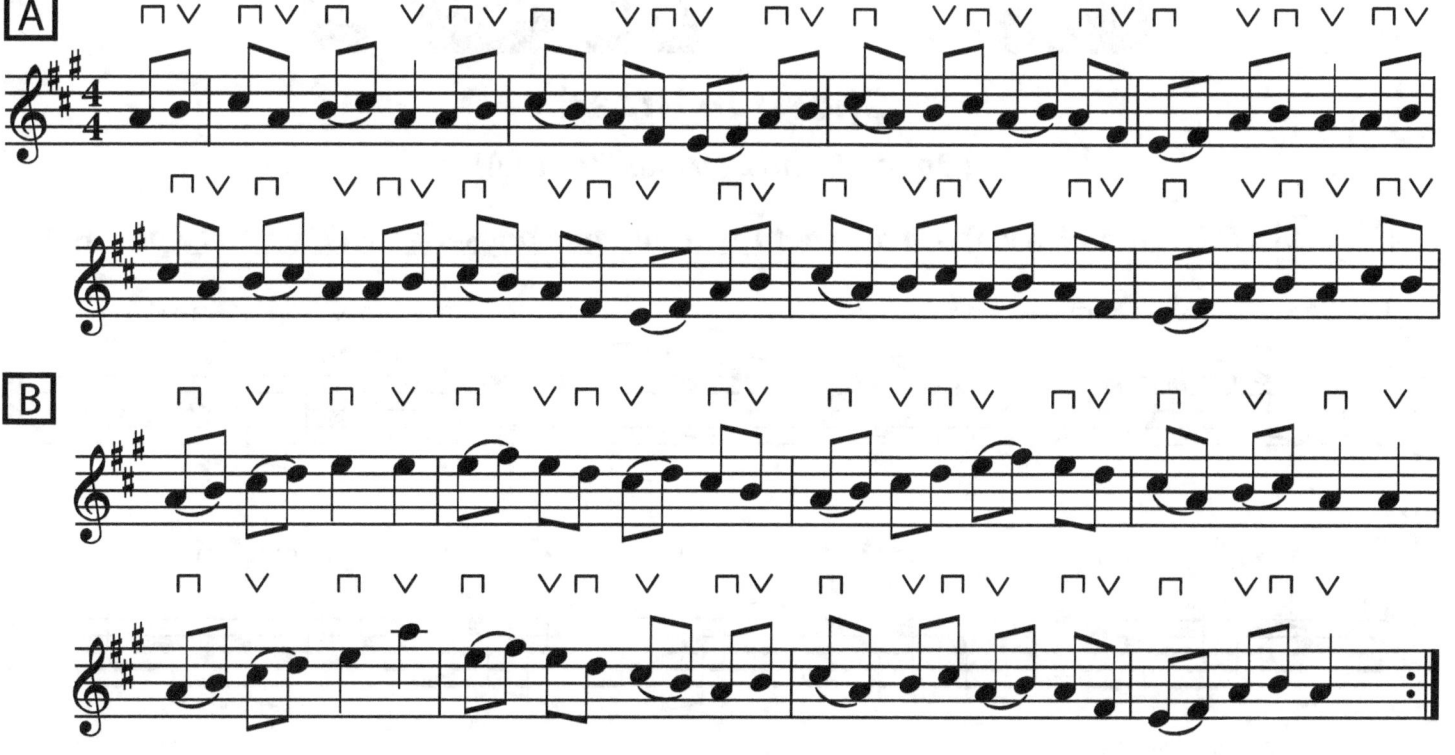

Eighth Of January

(On the D, A and E strings/Key of D)

▷VIDEO *(This is the 13th video in the youtube.com, Jamalongseries, Fiddle Book 2 playlist)*

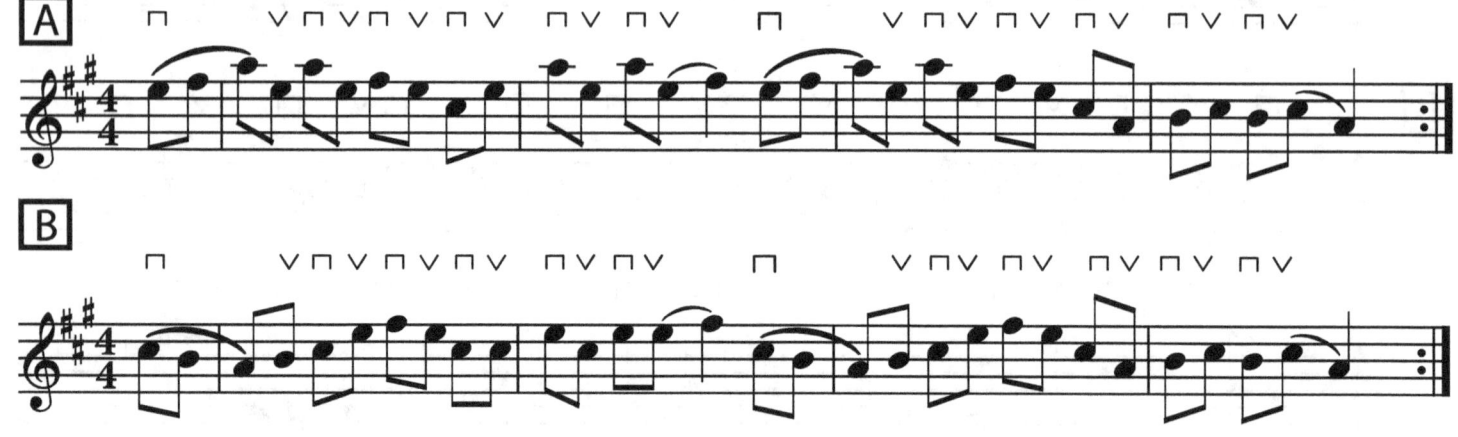

Shortnin Bread

(On the A and E strings/Key of A)

▷VIDEO *(This is the 14th video in the youtube.com, Jamalongseries, Fiddle Book 2 playlist)*

Boil The Cabbage (AABB)

(On the A and E strings/Key of A)

▶VIDEO **(This is the 15th video in the youtube.com, Jamalongseries, Fiddle Book 2 playlist)**

Swallowtail Jig

(On the D, A and E strings/Key of Em)

▶VIDEO **(This is the 16th video in the youtube.com, Jamalongseries, Fiddle Book 2 playlist)**

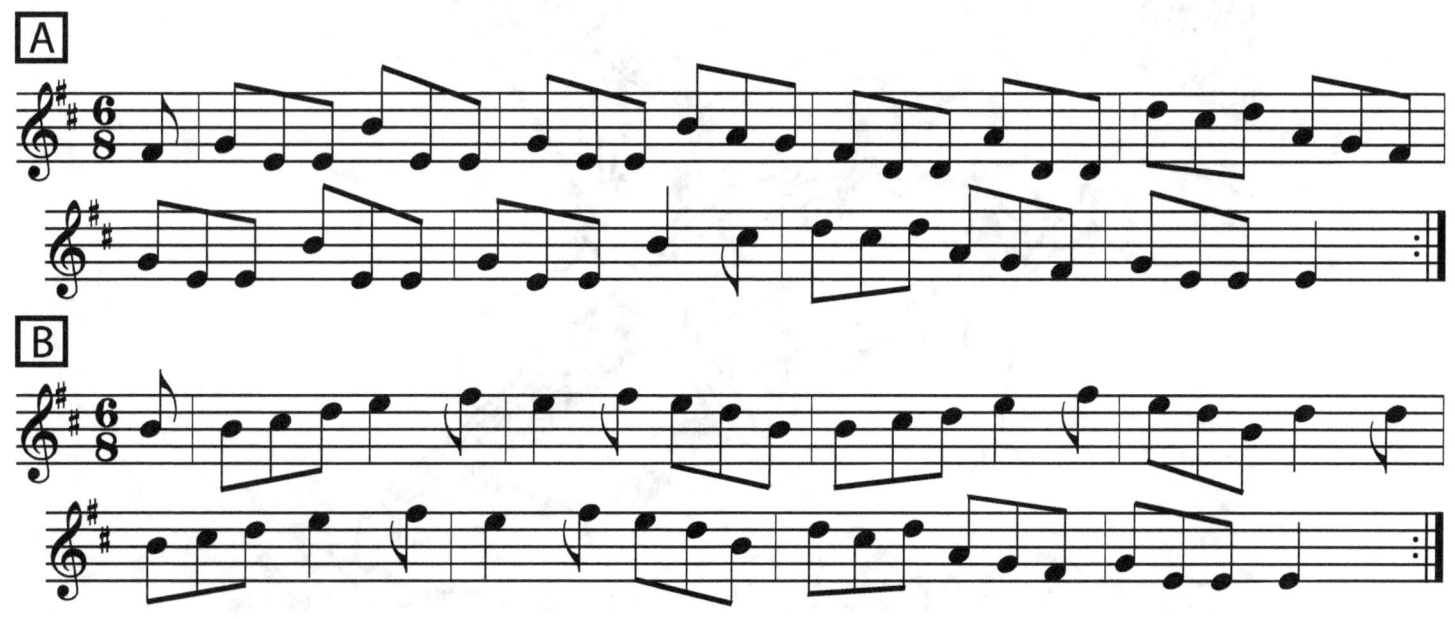

FIDDLE: BOOK ONE

Auld Lange Syne

(On the D, A and E strings/Key of G major)

(This is the 17th video in the youtube.com, Jamalongseries, Fiddle Book 2 playlist)

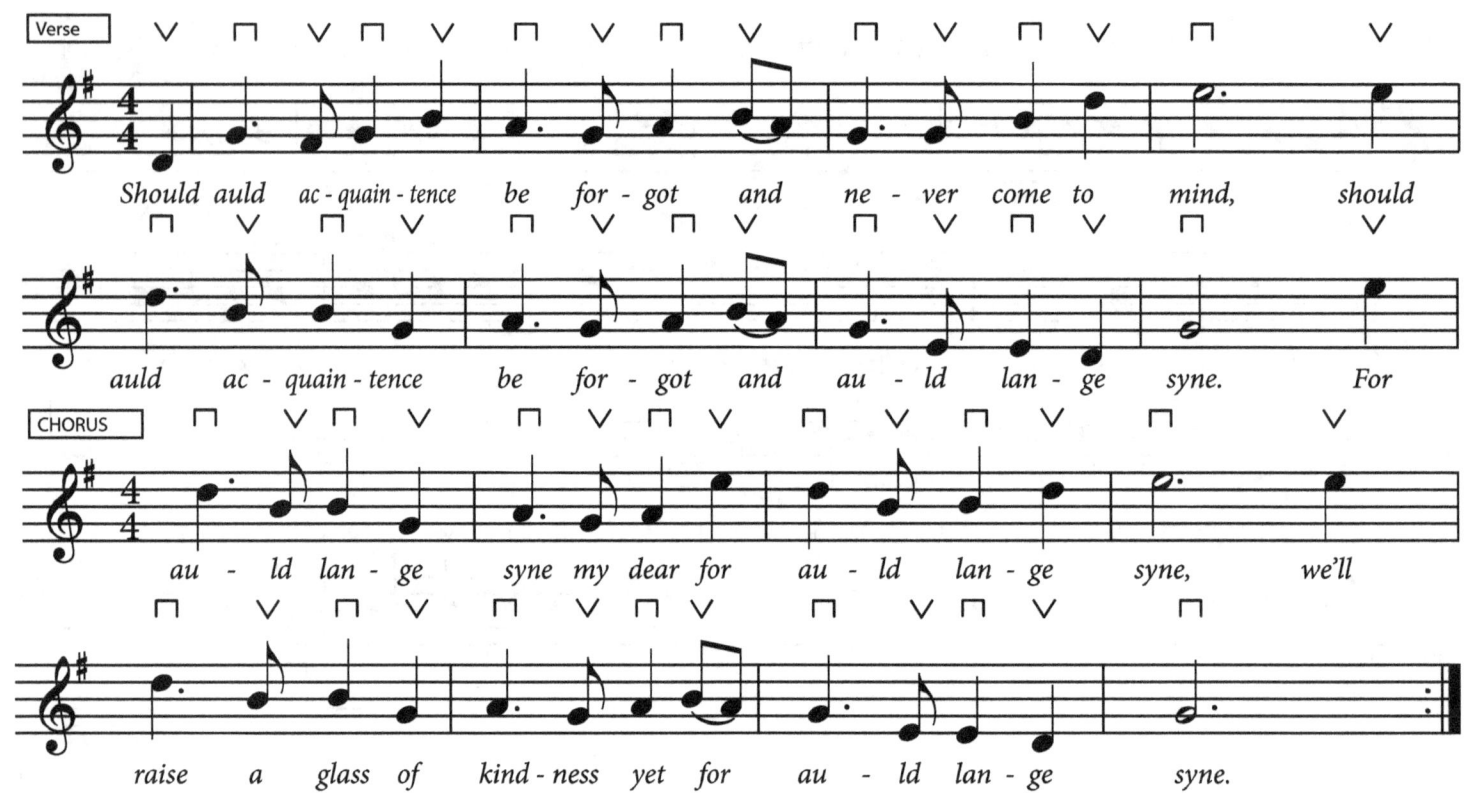

Angelina Baker
(On the D, A and E strings/Key of D)

▶VIDEO **(This is the 18th video in the youtube.com, Jamalongseries, Fiddle Book 2 playlist)**

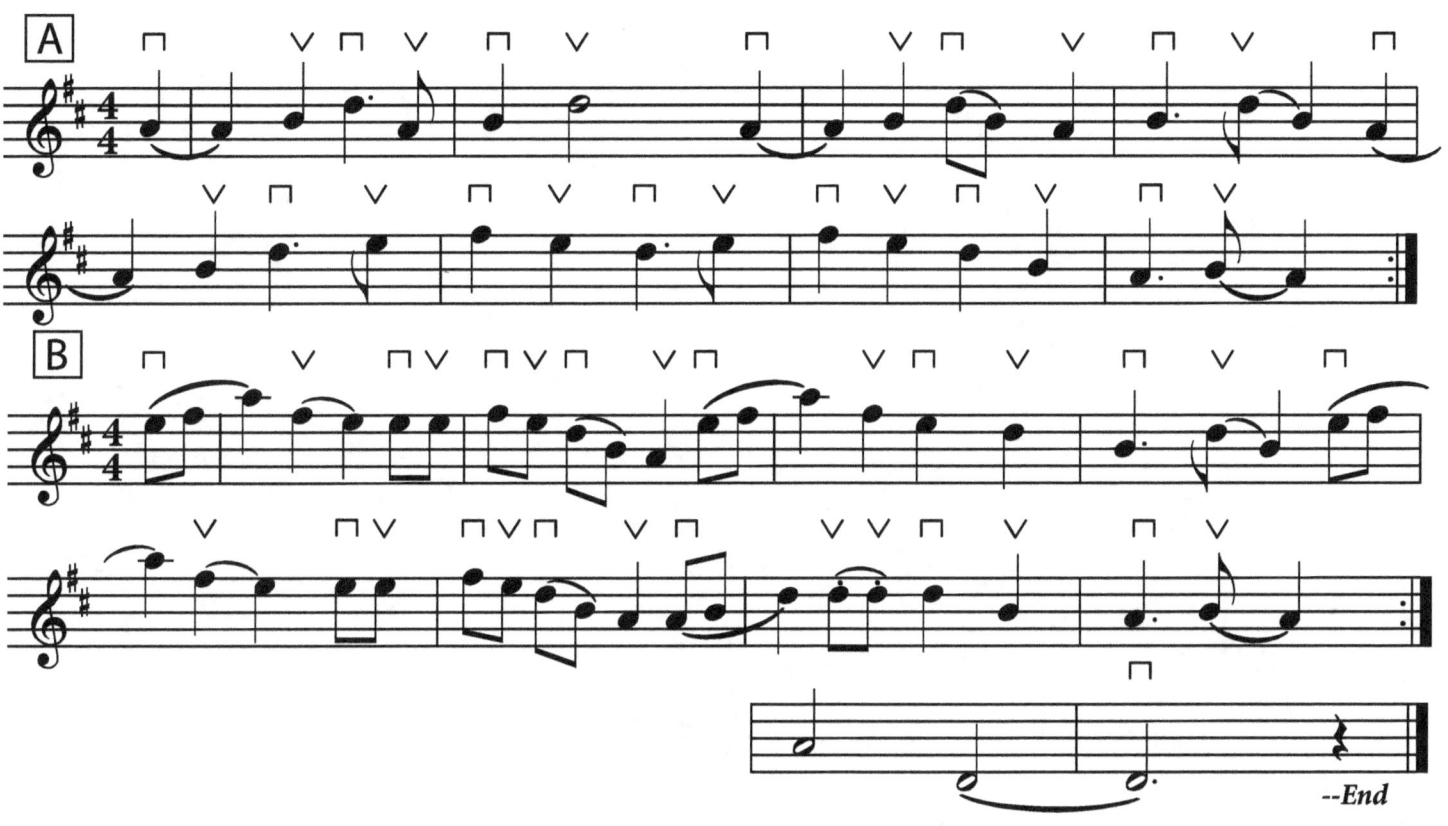

--End

Repertoire List

To the right is a Repertoire List of all the songs we have covered in this book. If you add these to what is covered in Book 1 we will have a total of 26 songs. I recommend memorizing these songs and becoming able to play them from memory.

1 Cripple Creek
2 Liza Jane
3 Wildwood Flower
4 Oh Susanna
5 Amazing Grace
6 Down In The Willow Garden
7 Sally Goodin
8 8th of Jan.
9 Shortnin Bread
10 Boil The Cabbage
11 Swallowtail Jig
12 Auld Lange Syne
13 Angelina Baker